MiXeD meDia
❧ H A N D B O O K ☙

EXPLORING MATERIALS AND TECHNIQUES

Kimberly Santiago

NORTH LIGHT BOOKS
CINCINNATI, OHIO
artistsnetwork.com

❧ CONTENTS

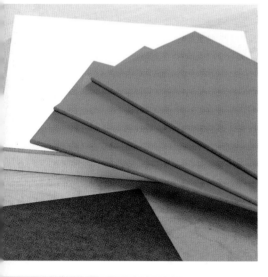

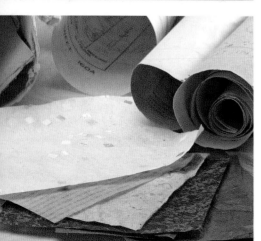

INTRODUCTION

Mixed Media Handbook is an easy-to-use reference of art materials and their relevance in creating mixed-media art. This book is intended to provide all age groups and skill levels a comprehensive guide to understanding art materials and supplies.

Written by a professional artist, this book offers in a logical sequence descriptions of the materials, tools and equipment that are currently and commonly used in creating mixed-media art and includes traditional and nontraditional materials.

Unlike other artist's handbooks, *Mixed Media Handbook* caters to the present-day artist. This book provides a complete and up-to-date accounting of the materials of their craft. It answers important numerous questions for the artists so they may have the greatest possible control over their materials. It also aids in the economy of their art, by ensuring they purchase the correct materials for their needs.

The most valuable advice I can offer outside of this resourceful book is that you make the effort to fully understand your materials before using them in your art. Many factors can affect the outcome of a mixed-media project. Although there are no guarantees, *Mixed Media Handbook* can help you to eliminate doubts and gain the confidence to make comprehensive decisions when being creative.

With its vast selection of materials, media and working processes, collage provides artists with a considerable number of productive techniques. Experimentation is essential for narrowing the almost countless possibilities to workable numbers; you will need to try several ways of combining methods and techniques. Your own personal interests in working processes, kinds of materials and goals or desired outcomes will dictate your major areas of exploration. For example, if you wish to create representational images, you should know that certain papers and techniques will be more efficient than others, so you can then sidestep scores of inappropriate collage combinations. Consider style, technique, and subject matter before you make final decisions.

When you begin experimenting, try various combinations of materials and techniques on small supports. Make notes on the back of each study to record materials, processes and problems. These notes will be very helpful as you further your creative explorations.

There are seven major areas to consider when investigating: basic materials and techniques supports, materials, techniques, adhesives, tools, surface-enriching media and finishes.

Collage supplies tend to differ greatly among the various personal techniques that artists develop. For example, there are numerous adhesives and methods of application, however only one is needed to build a collage—the one that is most appropriate for the materials and techniques employed. The same holds true for tools, other media and finishes. Experimentation, however, can involve additional materials and personalized selections.

Although there are many avenues to develop mixed-media art, they all begin with the same simple principles: gather your resources and materials, select a substrate, edit down your collage resources, select an adhesive, begin your first layer, embellish with other media and continue to repeat until you achieve the desired look.

Once you have chosen your collage materials, you then want to develop personal techniques for using them most effectively. Again, experimentation is the key to our successful solutions and discoveries. You should try various ways of cutting, tearing, adhering, overpainting, altering and finishing until you are satisfied that you are accomplishing two things: the most effective way to use materials, and a style that is representational of you. Experimental activities can best be carried out on small studies so that many possibilities can be explored in a short period of time.

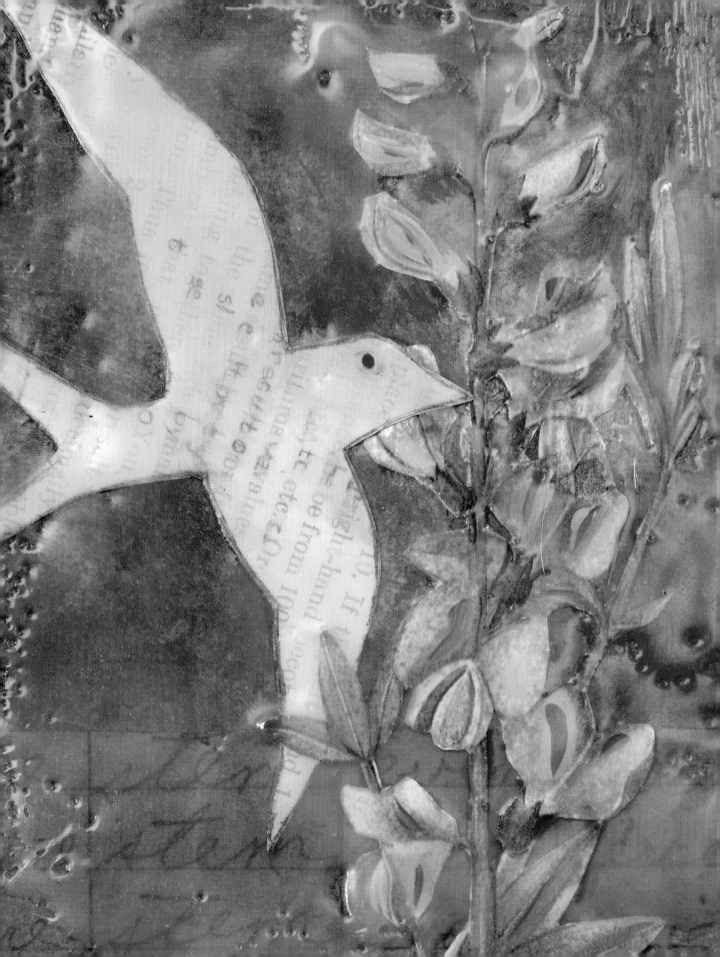

WHERE IT BEGINS

Substrates

Mixed-media art comes from a plethora of different places, and knowing just where to start can be daunting. Oftentimes, an idea is sparked from an existing material: a photograph, a letter, a bit of tile or a found object. Whatever the case may be, the selection of the substrate or the base is vital to the success of the artwork. This chapter helps to clarify which types of substrates to use for various types of projects and why to use them. The information covered in this chapter will aid you in your decision-making process while providing you with a clear understanding of the materials.

There are three basic categories of substrates: board, paper and textured. When choosing your substrate, consider what materials you'll be attaching and how you'll be attaching them. For instance, lightweight substrates may buckle under heavy objects or if wet mediums and adhesives are used.

The surface of the substrate is also important; consider whether or not it is porous and will grab adhesives or paints. Another consideration is flexibility. For example, rubber stamping on a stretched canvas would be difficult because of the give of the canvas. A more suitable substrate for stamping would be a solid panel or board.

When deciding on your substrate, consider the following:

- What type of surface do you want to work on? Hard and rigid or soft and flexible?
- Do you want the substrate surface to be smooth, slightly textured or rough?
- Does the substrate need to be archival? Is longevity a concern? What is the material content?
- Is the size or shape of the substrate important?
- How will you be attaching or adhering collage materials to the substrate?
- How heavy are the materials?

Whatever your selection, there are always suitable adaptations, which makes mixed media an enjoyable and versatile art form.

⚛ BOARDS

We have discussed a variety of substrates available commercially; now let's take a look at unconventional items that can be used in mixed media.

AQUABOARD

Aquaboard is an alternative to watercolor paper is and perfect for incorporating other media. Its archival, acid-free textured clay surface absorbs water like a fine paper, providing great color saturation and luminosity.

- Available in: single boards
- Excellent for: acrylic and watercolors
- Adhesive qualities: wet, dry or spray adhesives, good for moderate collage materials
- Keep in mind: textured surface, very absorbent

BRISTOL BOARD

Bristol board (also known as bristol paper) is an uncoated machine-finished paper board. It is most commonly white, but also comes in different colors. Canson offers a pad of bristol board with a distinct white surface—one side of the paper smooth and the other textured.

- Available in: vellum or smooth surface, single sheets, pad or box
- Excellent for: pencil, colored pencil, charcoal, pen, markers, soft pastels, oil pastels
- Good for: water-soluble paints, spray paints
- Adhesive qualities: wet, dry or spray adhesives, good for lightweight collage materials
- Keep in mind: may buckle with excessive wet media or adhesive, holds limited weight with mixed-media applications

CANVAS BOARD

Canvas board is stretched and constructed from heavyweight, medium grain poly-cotton cloth or linen secured to high quality boards. It is coated with acid-free sizing and is primed.

- Available in: unprimed and primed rolls, pre-stretched or boards
- Excellent for: all paints, ink, markers, pastels
- Good for: collage, pen, pencils
- Adhesive qualities: wet, dry or spray adhesives, good for lightweight collage materials
- Keep in mind: may buckle with excessive wet media or adhesive, holds limited weight with mixed-media applications

CARDBOARD

Cardboard is available in different weights and thickness. It is readily available and inexpensive. Product packaging (such as cereal boxes) can make interesting and creative surfaces. Apply only lightweight embellishments with this substrate.

- Available in: sheets, boxes, packages
- Good for: markers, some paints (test for saturation and buckling)
- Adhesive qualities: wet, dry or spray adhesives, good for lightweight collage materials
- Keep in mind: not archival, may buckle or bow with wet media or adhesive, paints do not saturate well, holds limited weight with mixed-media applications

CHIPBOARD

Chipboard is a rigid board with a smooth finish; it is normally used to mount artwork. It is usually gray or beige. Chipboards are the type of board used in for backing pads of paper. It will not support heavier embellishments.

- Available in: sheets
- Good for: oil pastels, markers, water-soluble paints, spray paint
- Adhesive qualities: good for lightweight to medium collage materials, wet, dry or spray adhesives
- Keep in mind: buckles with moderate to excessive wet media or adhesive, holds limited weight with mixed-media applications, not archival, paints do not saturate well

CLAYBOARD

This board is designed for mixed media. It has an acid-free, kaolin clay ground on a quality hardboard support. Its absorbent, velvet-smooth finish makes it great for mounting photos, fabrics and paper. The surface can be manipulated to vary tonal value, create detail, develop highlights and correct mistakes. (Ink can be completely erased without affecting

SUBSTRATES
Far left: Strathmore mixed-media board, vellum surface; Center back: Ampersand Claybord, multi-media, cradled ⅞" (.33cm); Upper Right: Ampersand Pastelbord, flat panels, Front Center: Ampersand Hardbord, flat pane

the integrity of the surface using an oil-free steel wool pad.) Scratching techniques also work well on this substrate.

- Available in: flat or cradled panels
- Excellent for: acrylics, air brush, encaustics, inks, tempera, painting, scratching techniques, Xerox or Polaroid transfer
- Good for: pencil, colored pencil, charcoal, pen, markers
- Adhesive qualities: good for lightweight to moderate collage materials, wet, dry or spray adhesives
- Keep in mind: smooth surface, very absorbent, quick drying time for inks and paint

CORK BOARD

Cork is a natural, renewable material. Its elasticity allows pins and other small objects to be inserted and removed without destroying the surface of the board. Cork's texture makes it an intriguing substrate. If you need the support of a solid surface, try a bulletin board. If you are looking for a more flexible surface, it's available in rolls or sheets. It also comes in a variety of sizes, shapes and thicknesses.

- Available in: sheets, rolls and boards
- Excellent for: attachment with push pins

- Good for: pencil, colored pencil, charcoal, pen, oil pastels, markers, water-soluble paints, spray paint
- Adhesive qualities: good for moderate to lightweight collage materials, wet, dry or spray adhesives, push pins or tacks
- Keep in mind: saturation qualities of the paint, may buckle or tear with heavy objects or excessive wet media or adhesive, holds limited weight with mixed-media applications

CORRUGATED FIBERBOARD

Corrugated fiberboard is a paper-based material consisting of a fluted corrugated sheet and one or two flat liner boards. It is inexpensive and readily available.

- Available in: sheets, boxes, packages
- Good for: markers, some paints (test for saturation and buckling)
- Adhesive qualities: wet, dry or spray adhesives, good for lightweight collage materials
- Keep in mind: will buckle with wet media or adhesive, holds limited weight with mixed-media applications, not archival, paints do not saturate well

DISPLAY BOARD

Display board (also called project or presentation board) may be constructed with corrugated cardboard, corrugated polypropylene board or foam board. Most have white clay-coated surfaces. It offers rigid lightweight support for mounting collage materials. Most are self-supporting and have fold-out side panels.

- Available in: single boards
- Good for: acrylics, pencil, colored pencil, charcoal, pen, markers, water based paints, spray paints
- Adhesive qualities: good for lightweight to moderate collage materials, wet, dry or spray adhesives
- Keep in mind: saturation qualities of the paint, may buckle with heavy objects and excessive wet media or adhesive, holds limited weight with mixed-media applications, not archival

ENCAUSTIC BOARD

Encaustic board is a ready-to-paint, highly absorbent surface that can handle many layers of wax and heat. There is no fear of cracking or warping.

- Excellent for: encaustics
- Adhesive qualities: good for lightweight to moderate collage materials, wet, dry or spray adhesives
- Keep in mind: smooth surface, very absorbent

FOAM CORE

Foam core or foam board is a light core of polystyrene foam bonded between two layers of paper. It has a smooth surface and is available in different sizes and thicknesses, as well as different varieties: colored, self-adhesive and a specially formulated version for dry-mounting applications with mechanical and vacuum presses. It is strong, durable, warp resistant (always test application) and cuts easily for sharp clean edges.

- Available in: single boards, white and color
- Excellent for: screen printing
- Good for: pen, markers, paints
- Adhesive qualities: good for lightweight to moderate collage materials, wet, dry or spray adhesives
- Keep in mind: saturation qualities of the paint, may buckle with heavy objects or excessive wet media and adhesive, holds limited weight of mixed-media applications

GESSO BOARD

Gesso board is acid-free gesso on a hardboard support. It is lightly textured for proper adhesion and is an alternative to canvas. Premium gesso boards provide a barrier between the wood substrate and the painting surface. Because it is pre-primed with gesso, no preparation is necessary.

- Excellent for: traditional water-based oils, alkyd, acrylics, collage and mixed media
- Adhesive qualities: good for moderate to heavy collage materials, wet, dry or spray adhesives
- Keep in mind: smooth surface, very absorbent

HARDBOARD

Hardboard is an unprimed, ultra-stable, formaldehyde-free, moisture-resistant panel surface, excellent for multiple layers of paint. It offers an archival alternative to stretched canvas.

- Excellent for: all paints, especially non-flexible media like tempera, casein and encaustic
- Adhesive qualities: good for moderate to heavy collage materials, wet, dry or spray adhesives
- Keep in mind: smooth-surface, non-absorbent

ILLUSTRATION BOARD

Illustration board is a thick paper-based surface. It's multi-ply, easily cut and formed, lightweight and strong. It's available in hot- and cold-pressed and is durable for mixed media applications. Cold-pressed boards feature a white, medium tooth that works well with all wet and dry media. Hot-pressed boards feature a white uncoated surface perfect for markers and ink. It's the surface of choice for illustration media.

- Available in: single boards
- Excellent for: inks, markers, paints
- Good for: oil pastel and soft pastel
- Adhesive qualities: good for lightweight to moderate collage materials, wet, dry or spray adhesives
- Keep in mind: saturation qualities of the paint, may buckle with heavy objects and excessive wet media or adhesive

MATBOARD

Matboard is typically used in framing and mounting artwork. It's available in a variety of colors and surfaces and tends to take well to minor surface additions, including pen and ink and paint. Cloth-covered mats are thicker and have more textural qualities. Because they are usually used in

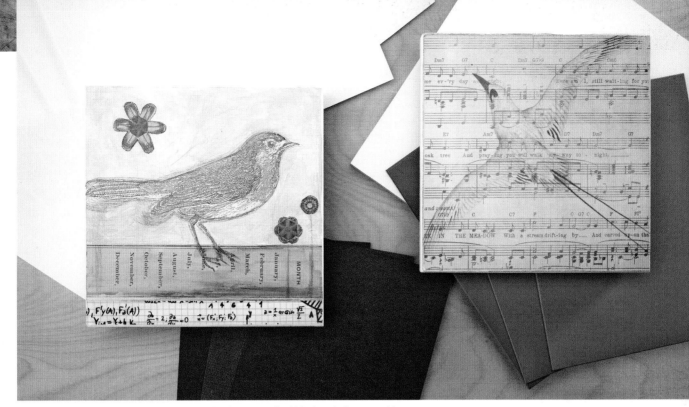

Both of these pieces of art where created using a cradled birch painting panel from American Easel, LLC as the substrates. The images were printed on Grafix Rub-onz transfer film. The piece on the left is embellished with Washi Tape.

framing, matboard is acid-free and has good archival qualities.

- Available in: single boards
- Excellent for: mounting art and photos
- Good for: inks, markers, paints, pastels
- Adhesive qualities: good for lightweight to moderate collage materials, wet, dry or spray adhesives
- Keep in mind: saturation qualities of the paint, may buckle with heavy objects and excessive wet media or adhesive, holds limited weight for mixed-media applications

MIXED-MEDIA BOARDS

Mixed-media boards are 100 percent cotton surfaces that are sturdy, archival, acid-free and two sided. Media will adhere to the surface without penetration. The finely textured surface erases well and blends easily. It can also be scraped and sanded. The front and back are both usable surfaces.

- Available in: packs of single boards
- Excellent for: all media, especially oil- and water-based paints
- Adhesive qualities: good for moderate to heavy collage materials, wet, dry or spray adhesives

- Keep in mind: the amount of weight held for mixed-media applications may vary

PANELS

Panels are multiple art application surfaces ideal for mixed media. Composed of pressed wood, they resist warping and moisture penetration. They are also great for mounting photos, canvas, papers or prints. Panels are sometimes referred to as "boards."

Manufacturers like Ampersand offer panels in a variety of options suitable for a range of media. Many of these panels are available in different surface types and profiles.

- Excellent for: all media
- Adhesive qualities: good for moderate to heavy collage materials, wet, dry or spray adhesives
- Keep in mind: various surface types, archival

PASTEL BOARD

Pastel board is an acid-free surface that holds more pastel layers than any other surface. The pastels will blend beautifully, and colors will be rich and vibrant.

- Excellent for: paints, especially pastels and acrylics

- Adhesive qualities: good for lightweight to moderate collage materials, wet, dry or spray adhesives
- Keep in mind: textured surface, archival, clay-coated

POSTER BOARD

Poster board is available in different sizes and strengths and can be clay coated on one side. Clay-coated poster board is bleed-and-fade resistant and accepts all sign painting media and vinyl lettering. Apply only lightweight embellishments.

- Available in: single sheets, white or color
- Good for: tempera, acrylic paints, pen and ink, markers, airbrush, silk screen and other print medium (test for saturation and buckling)
- Adhesive qualities: dry or spray adhesives, good for lightweight collage materials
- Keep in mind: will buckle or warp with wet media or adhesive, holds limited weight for mixed-media applications, not archival

RAILROAD BOARD

Railroad board is four-ply and recyclable. It's available in many colors and great for construction, art projects, mats, mounting, block printing and stenciling.

- Available in: sheets, white or colors
- Good for: tempera, acrylics, pen and ink, markers, airbrush, silk screen and other print medium (test for saturation and buckling)
- Adhesive qualities: dry or spray adhesives, good for lightweight collage materials
- Keep in mind: will buckle with wet media or adhesive, holds limited weight for mixed-media applications, not archival

SCRATCH BOARD OR PANEL

This smooth, acid-free, absorbent kaolin clay surface has an even coat of India ink, allowing for precision and control when scratching. It is a rigid surface that will not tear, puncture, crack or bend.

- Excellent for: scratch techniques with ink, paint and mixed media
- Adhesive qualities: good for lightweight to moderate collage materials, wet, dry or spray adhesives
- Keep in mind: specialized scratch board tools recommended

How Does Weight Determine the Thickness of Boards and Paper?

Two ways of expressing paper density (basic weight and grams) are commonly used:

1. Expressed in terms of the mass (expressed as weight) per number of sheets, is known as basis weight. This is the standard commonly used in the United States and a few other countries using US paper sizes. To determine the strength of the substrate, note that paper thickness is measured by the weight and is stated using the # (or pound) symbol. For example, *20# means twenty pounds per basis ream of 500 sheets*. The weight is calculated by a straight formula to help paper suppliers with consistency and shipping cost. The thing to remember is a pad of paper that is labeled *20#* helps you identify the thickness and weight of the paper. Therefore, if you want a heavier or thicker sheet of paper, select a higher weight or number.

2. Expressed in grams per square meter (g/m2), paper density is also know as grammage. This is more commonly used in Europe. Paper density is a measure of the area density. Paper products that let little or no light pass through (poster board) are considered dense or heavy (grammage of 220 to 250). Paper products that allow some light to pass through (tissue paper) are considered lightweight (grammage of 135 or less).

Unlike paper, boards are measured in point size. A micrometer is used to measure thickness, point size or a caliper is 1/1000 of an inch. Chipboard and poster board come in several sizes and thicknesses. The most common poster board is .020 (or 20 point size) and chipboard is .050 (or 50 point size). So, again the heavier or thicker you want the board, the higher the number or point size.

❧ PAPER

Paper is available in different working surfaces: smooth and vellum (more texture), for example. Paper weights are measured in pallet weights. The heavier the pallet, the thicker or heavier the paper. For example, 200-lb. paper (425gsm) is thicker than 100-lb. (210gsm) paper. Paper is a reasonable substrate for mixed media, just be aware of how many layers (wet or dry) you may add and whether the paper will warp or pucker. Always test paper before introducing it into your mixed-media projects.

There are different categories of paper with respect to sizing. The degree of size in a paper relates to its absorption and water resistance. Slack-sized paper is somewhat absorbent and includes newsprint, while hard-sized papers have a higher resistance to water and include coated fine papers.

ACRYLIC PAPER

Acrylic paper is a heavyweight, versatile, acid-free and well suited for a variety of applications. It comes in a range of size and thickness and its toothy surface provides "grab" for the medium. It won't buckle and is ready for use with water-based media, so no need for gesso or other preparation. Its sizing provides the ideal level of absorbency for water-based media.

- Available in: sheets and pads
- Excellent for: all water-based paints, ink, markers, pastels
- Good for: collage, pen, pencils
- Adhesive qualities: wet, dry or spray adhesives, good for lightweight collage materials
- Keep in mind: may buckle with excessive wet media or adhesive, holds limited weight for mixed-media applications

BOND PAPER

Bond paper is also known as copy paper. The name originated from its use by the government in making government bonds. Although it is a quality paper to use for copies and printing, it does not lend itself well to mixed media,

especially wet media. However, I have used copies within my art and it has been fine. The key is to know how to apply the media and the appropriate use.

- Available in: sheets, pads and reams
- Good for: pen, pencils
- Adhesive qualities: dry or spray adhesives
- Keep in mind: may tear or pucker with wet media or adhesive, the amount and types of layers in mixed-media applications

CARD STOCK

Card stock is also known as cover stock. It is thicker than bond paper. It comes in a wide variety of colors and textures. Card stock is often used for postcards, business cards and scrapbooking. The texture can be smooth, textured, mirrored, metallic, matte or glossy.

- Available in: sheets, pads and reams
- Good for: pen, pencils, some paints
- Adhesive qualities: dry or spray adhesives
- Keep in mind: may tear or pucker with wet media or adhesive, holds limited amount and types of layers in mixed-media applications

ILLUSTRATION PAPER OR PAD

Illustration paper is commonly used with pen and ink, pencil or marker. The paper is usually about 150-lb. (315gsm), in extra or bright white.

- Available in: sheets and pads
- Good for: Pen and ink, pencils, markers
- Adhesive qualities: dry or spray adhesives
- Keep in mind: May tear or pucker with wet media or adhesive, holds limited amount and types of layers in mixed-media applications.

MIXED-MEDIA JOURNALS, CARDS AND ART BOOKS

Mixed-media journals and books are high quality, come in a range of sizes and paper weights, are durable and beautiful. They offer strong front and back support. They are acid-free, 100 percent cotton, have excellent erasability, are sized and of archival quality. Wire binding allows some journals to lie flat.

Mixed-media cards are made from high quality, heavy weight mixed-media paper. They have the attributes of a watercolor paper, but with a vellum drawing finish, so they deliver a true performance for both wet and dry media.

- Available in: pads, art books, journals and cards

- Excellent for: collage, watercolor, gouache, acrylic, graphite, pastel, pencil, colored pencil, charcoal, pen, ink, markers
- Adhesive qualities: great for light to medium weight collage materials (boards may hold medium to heavy weight collage materials), wet and/or dry adhesives
- Keep in mind: may buckle with excessive wet media or adhesive; some art books offer pages that may be removed and reinserted, making single-page projects or moving pages around easy

MIXED-MEDIA PAPER

Because mixed-media art has become so popular, many quality paper companies now offer paper exclusively made for mixed media. They may be found in a variety of packaging: pads, books and boards.

Mixed-media boards are ready-cut boards for ready-made frames and mats. They have a vellum surface, 52 point thickness, 100 percent cotton surface, and are two sided for wet and dry media. They are archival and acid-free.

Mixed-media pads range in size and weight. They are acid free, accept wet and dry media and come in a range of sizes. They may be tape bound at the top or spiral bound with perforated pages. They range in weight from 90–140-lbs. (190gsm–300gsm).

Wet-media pads are heavyweight, multi-purpose paper for use with wet media such as watercolor, acrylic, gouache and ink. This paper has a textured surface which is great to use with pastels.

- Available in: packs of single boards, pads
- Excellent for: watercolor, gouache, acrylic, graphite, pastel, pencil, colored pencil, charcoal, pen, ink, markers, collage
- Good for: encaustic
- Adhesive qualities: great for light to medium weight collage materials (boards may hold medium to heavyweight collage materials), spray, wet or dry adhesives, may buckle with excessive wet media or adhesive

PAPER VELLUM

Paper vellum usually refers to two distinct kinds of paper: drafting vellum and bristol vellum. Drafting vellum (sometimes called design vellum) is a fantastic option for tracing or technical drawing. This translucent paper comes in thin sheets that can be clear, white or colored. It has archival quality with great strength and erasability (with no ghosting).

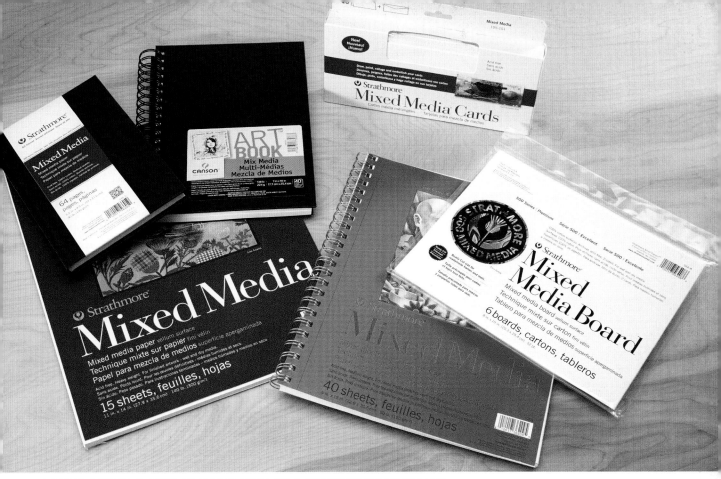

MIXED-MEDIA PAPER IS AVAILABLE IN A VARIETY OF FORMATS

Aside from being thin enough to allow light through, there is no specific weight, texture or set of qualities that specifically defines vellum.

- Available in: packs of single sheets, pads, white and metallic colors
- Excellent for: translucence and layering
- Good for: photo copies, pencil, ink
- Adhesive qualities: dry or spray adhesives
- Keep in mind: will buckle or pucker with wet media or adhesive

PRINTMAKING PAPER

Printmaking paper is usually a more flexible or pliable paper, meaning it's softer. I like to use printmaking paper when I sew an embellishment. This paper is also great for embossing and foil stamps. Most printmaking papers are 100 percent cotton and acid-free. They come in machine-made or mold-made sheets with two to four deckled edges, and have a smooth surface. It is great for book and journal arts. The weight is usually measured in grammage, however, some manufacturers use pounds.

- Available in: packs of single sheets
- Excellent for: printmaking
- Good for: encaustic
- Adhesive qualities: good for light weight collage materials, spray, wet or dry adhesives

WATERCOLOR PAPER

Substrates for watercolor are available in paper, boards and canvas offered in a variety of surface types and weights. There are many characteristics that you need to consider when making a watercolor paper selection for your project.

The texture or surface finish on the paper will give you different effects. You can choose from three conventional surface textures: hot-pressed (smooth surface texture), cold-pressed (slightly bumpy surface texture) and rough (the bumpiest surface texture). Stretching watercolor paper is optional.

Watercolor paper weight is measured in pounds. Each weight has its advantages, and the weight you choose should depend on what you would like create. Typical weights are: 90-lb. (190gsm), which is thin and does not have a high endurance for wet media layering; 140-lb. (300gsm) paper is the mid range and usually the most popular choice (It is fairly stout and can be stretched to avoid excessive buckling.); and 300-lb. (640gsm) paper, which is thick like a board and does not require stretching in order to prevent or reduce buckling.

- Available in: single sheets, pads, rolls
- Excellent for: watercolor
- Good for: mixed media
- Adhesive qualities: dry adhesives, may buckle with wet media or adhesive
- Keep in mind: the thicker the paper, the longer the drying time

WATERCOLOR BOARD

Watercolor board is basically watercolor paper adhered to illustration board. It does not buckle when wet and is available in sizes up to 20" × 30" (51cm × 76cm).

- Available in: boards, single sheets, pads, rolls
- Excellent for: watercolor
- Good for: mixed media
- Adhesive qualities: wet, dry and spray adhesives
- Keep in mind: the thicker the paper, the longer the drying time

What Is the Difference in Paper Finishes?

The names of paper finishes refer to how the paper was made. This process is what creates the differences in texture and performance.

- **Hot-pressed.** Think of hot-pressed paper as ironed paper. After it is made, hot-pressed paper is pressed flat with hot rollers. This is what gives it a very smooth surface. Hot-pressed paper is good for demonstrating details in drawing or painting and has a smooth surface on which to adhere collage items.
- **Cold-pressed.** This paper has a slight nubby texture to it. Because it was not pressed with a hot roller, the paper has a rougher texture than hot-pressed paper. Artists who use cold-pressed paper are more relaxed in their strokes and enjoy how the rough texture makes the medium settle in unpredictable ways. Collage resources that are adhered to a cold-pressed substrate may pick up the texture from underneath, adding to the dimension of the art. Just something to think about.
- **Vellum surface.** Keep in mind that the word vellum may refer to the type of paper or the surface of the paper. In this case, we are referring to the surface of the the paper. A vellum surface is quite smooth, it's surface characterized by a velvety feel. Vellum-surface paper is perfect for printmaking.
- **Rough surface.** This paper is usually limited to watercolor paper. This surface texture is similar to cold-pressed paper but with a even more textured surface.

TEXTURED SUBSTRATES

Textural substrates refers to different and sometimes unconventional materials. In this section we will look at fabric (including canvas), glass (Plexiglas), metal, tile and wood. These materials can be found, purchased or made. Their unique qualities make them an interesting choice for mixed media.

CANVAS

Canvas is available raw (unprimed) or prepared (primed). Oil-primed canvas is normally used only with oils. Acrylic-primed is used with virtually any medium. Linen makes the finest canvas generally used for critical work and fine techniques. Cotton makes fine quality canvas, is more economical than linen, and is widely used by fine and commercial painters. Canvas will work as a substrate for mixed-media projects. Apply only light weight embellishments—wet adhesive works best. Canvas is available stretched and unstretched. Unstretched canvas may be stretched and stapled to stretcher strips. Stretcher strips feature tongue-and-groove design, are made of ponderosa pine molding, and are available in many sizes.

- Available in: board, stretched frame, single sheets, pad and rolls
- Excellent for: all paints, inks
- Good for: mixed media
- Adhesive qualities: dry and wet adhesives
- Keep in mind: Canvas stretched over stretcher bars or wood frames will have more give or spring. This may not be a good surface for techniques that require a more rigid substrate (like rubber stamping).

BLOOM
This layered artwork incorporates the glass from a standard clip frame as part of the substrate. The flower image was printed on Grafix computer clear adhesive-backed ink-jet compatible 8½" × 11" (22cm × 28cm) sheet and adhered to the front of the glass. A painted map was cut to size and inserted under the glass. The beauty of this project is that it is interchangeable. To create a new look, you can simply remove the painted map and replace it with something different.

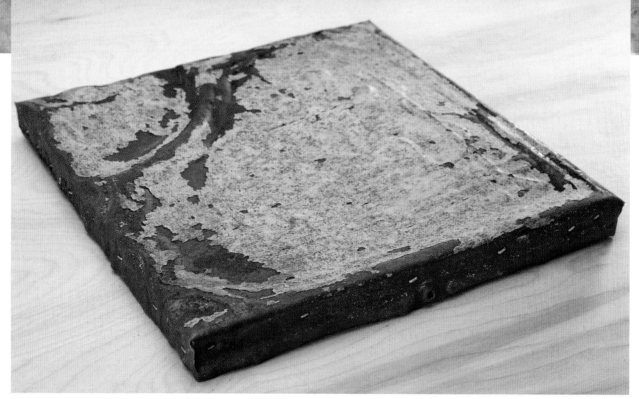

CEILING TILES AS SUBSTRATES
This vintage ceiling tile was cut, bent and stapled over a piece of plywood. Ceiling tiles can also be used in their original form.

FABRIC

Textile artists and craftspeople have made fabric a desirable element to incorporate within mixed-media artwork. And considering the availability of so many commercial textiles and vintage items, adding bits and scraps to an art piece is almost a given. The things that are important to consider are the adhesive process and durability of the textile.

Using a textile for a substrate is similar to canvas. The textile can be stretched over stretcher bars or a wood frame if it is pliable enough. Or you may choose to allow the textile to keep its natural form.

There are several adhesives tested and marketed for textile application. Take the time to discover which will work best for you. The advantages of using a wet adhesive is that the cost is low. However, disadvantages include drying time and limitations on where it may be applied. You can also come across bleed problems, depending the types of dyes or paints in the textile. Adhesives to consider: textile or fabric glue, fusible webbing (heat-induced adhesive), sewing and double-tack adhesive film.

Painting or printing on a textile substrate is one way of achieving the exact color and design you want to have in your mixed-media artwork. There are several options available depending on the type of textile substrate, the weight of the fabric, the texture or surface, the type of fabric and the content of the fabric (cotton or synthetic).

- Available in: yardage, bolts, rolls, vintage pieces
- Excellent for: all paints, inks, stencils, sewing
- Good for: mediums, markers, oil pastels
- Adhesive qualities: dry (includes fusible webbing), spray and wet adhesives
- Keep in mind: Textiles will have more give or spring. This may not be a good surface for techniques that require a more rigid substrate (like rubber stamping).

GLASS OR PLEXIGLAS

Using glass or Plexiglas as a substrate has distinguished qualities. The mixed media may be applied to the front or back (face forward) of the glass. The key thing to remember when applying elements to the back (face forward), is that you are working in reverse. In other words, it is imperative to know that the foreground is the first element applied and the background is the last. This is the direct opposite of creating traditional two-dimensional artwork.

Glass and Plexiglas come in different sizes and thicknesses. Plexiglas is an acrylic "glass" often used as alternative to glass. It is lighter in weight, shatter-resistant and scratches easier. You may cut Plexiglas with Plexiglas cutting tools.

Using glass as a substrate can be slightly tricky because it is breakable. Another consideration to note is that the edges are sharp and can harm you. When working with glass as a substrate, it is recommend that you tape or sand the edges to help reduce the risk of injury. Glass-cutting tools are available in most craft and hobby stores.

- Available in: single sheets, transparent, colored, opaque
- Excellent for: etching (glass only), glass paint
- Good for: acrylic and latex paint, permanent markers, vinyl adhesive, lightweight collage materials
- Adhesive qualities: spray, dry and wet adhesives
- Keep in mind: For vintage windows used as a substrate, specialized products may be needed

METAL

Using metal as a substrate is similar to using glass as metal has a solid surface and not much flexibility. Metal edges can be sharp and cause injury. The different types of metal can respond differently to mixed-media applications. For instance, copper and bronze's natural qualities are to oxidize and patina. This look is quite beautiful, but only if you had that in mind. There are specialized adhesives for metals such as metal epoxy adhesive (which sets in 5 minutes with a final cure color of light gray). Common metals for substrates include: bronze (old statue), copper (vintage tile), iron (cast iron items), tin (everyday cans), aluminum (containers), and flashing (sold in hardware stores).

- Available in: rolls, Sheets, tiles, furniture, everyday and vintage pieces
- Excellent for: repurposing discarded items into mixed-media art, drilling into, hammering, sawing, cutouts or shapes, mounting embellishments
- Good for: paints for metal, markers, oil pastels, collage
- Adhesive qualities: dry, spray and wet adhesives
- Keep in mind: Specialized products may be needed. Test materials before application. Always read manufacturers' directions and remember to follow safety information.

STEEL SUBSTRATES
This 5" × 7" (13cm × 18cm) .013 tin coated steel from K+S Precision Metals can be purchased at most craft and hobby stores.

TILE

When using tile as a substrate you need to consider the surface. Tiles may be porous or nonporous. This information will help you decide what type of adhesive and mediums to use. Tiles are available in hardware stores and they can be handmade. Tiles can be composed of ceramic, porcelain, wood, stone, metal, glass or paper. We usually use the word tile when we are referring to flooring or kitchen tile. However, roof tiles are available in different sizes and shapes, too. And the paper squares used in Zentangles are called tiles.

- Available in: ceramic, porcelain, wood, stone, metal, glass, paper
- Good for: paint, collage, decals
- Adhesive qualities: dry and wet adhesives
- Keep in mind: Tiles are breakable. Test materials before application to art. Always read manufacturers instructions and remember to follow safety information.

WOOD

This section looks at more of the nontraditional wood substrates such as raw wood, drift wood and cabinet doors—wood pieces that are not found in an art store. Problematic features of using nontraditional wood pieces include the surface areas themselves. Always test an area of the substrate to see how adhesive and other mediums are going to perform. Finishes on existing wood substrates can be addressed by sanding or stripping. Products like liquid sander can help with this preparation.

Drift wood is very dry and can be extremely absorbent. An overall good quality of using wood as a substrate is that you are able to drill, hammer, saw cutouts and otherwise mount embellishments. Therefore, this substrate can be quite versatile.

- Available in: raw, building supplies, cabinet doors, door frames, furniture, drift wood
- Excellent for: drilling into, hammering, sawing cutouts or shapes, mounting embellishments
- Good for: most paints, markers, pencils, inks, mediums, collage
- Adhesive qualities: dry, spray and wet adhesives
- Keep in mind: Test materials before application to art. Certain finishes may require preparation.

Stretching Watercolor Paper

Stretching watercolor paper has certain aesthetic advantages, most nortably, you will end up with a hard flat surface to work on. Thinner papers (140gsm and less) will most likely buckle if you do not stretch them.

Begin by filling a large tub with 6" of lukewarm water. Submerge the paper and let it soak for 5-10 minutes. Carefully remove the paper from the tub. Lay it on a flat surface and gently smooth the paper with a clean sponge to remove excess water.

Is the paper wet enough? You can determine if the paper is wet enough by bending a corner. If it springs back, it's not wet enough. You will need to soak it longer.

Place the wet paper on a solid board, like Masonite or a sealed plywood that is at least ⅜" thick. Use a heavy-weight craft paper tape with a water-soluble adhesive coating on one side. Cut tape into strips, moisten with wet sponge and tape all four edges to the back of the board. Lay the board flat while the paper dries.

Painted Map Substrate

Follow the steps to create a substrate by painting and stretching a map.

MATERIALS 1" (2.5cm) flat brush paint canvas stretcher bars staple gun

1 **PRIME THE MAP PAPER**
Use a 1" (2.5cm) flat brush to paint onto the map surface as desired. Let the paint dry.

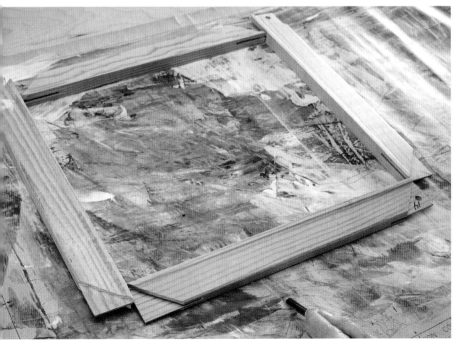

2 **CONFIRM MEASUREMENTS**
Lay out stretcher bars and trace to the approximate size needed to cut out.

3 PUT IT TOGETHER

Fit the stretcher bars together by connecting the tongue-and-groove bars. You may have to gently rock the bars to secure.

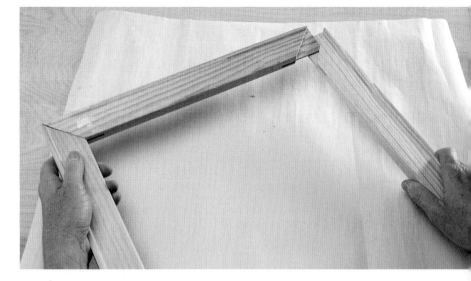

4 FOLD AND STAPLE

Fold the edge of the paper under and staple in the center of the stretcher bar. Move to the opposite side and repeat until all four sides are stapled.

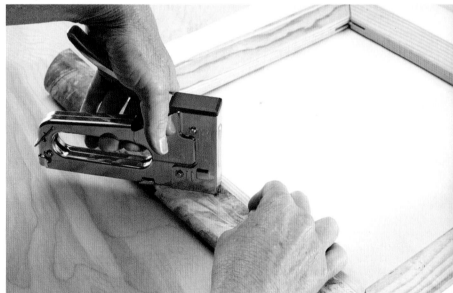

5 FINISH WITH THE CORNERS

Complete the stretching process by folding each corner and securing it with a few staples. This corner-folding technique is similar to wrapping a gift.

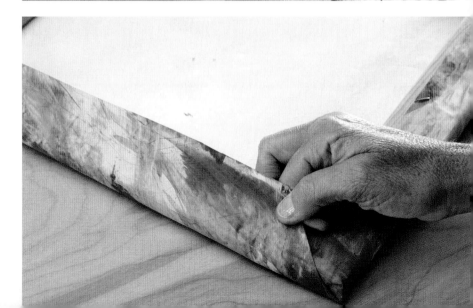

FINISHED EXAMPLE
A finished example of artwork with a painted-map substrate.
Optional stitching can be added with a sewing machine or
handstitching.

Did You Know?

Deckle refers to the removable wooden frame or
"fence" used in manual paper-making. This paper-
making process can lead to paper with a feathered
edge, described as a "deckled edge."

❦ UNCONVENTIONAL SUBSTRATES

Using a textile for a substrate is similar to using canvas. The textile can be stretched over stretcher bars or a wood frame if it is pliable enough. Or you may choose to allow the textile to keep its natural form.

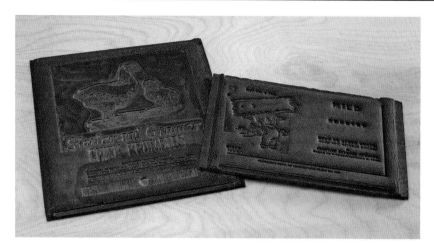

VINTAGE PRINTING PLATES

I was intrigued with the imagery and lettering on the plates and decided to use them as substrates. In this photo, you can see that they are dark brown on the front and embossed with imagery and lettering. They are also flat and paper-backed with handwritten reference numbers. They come in an array of shapes and sizes.

PRINTING PLATES AS SUBSTRATES

Here you can see printing-plate substrates as a work in progress. I began by painting the smaller surface and adding a small metal perfume pendant. The larger plate was painted with acrylic paints and embellished with a flower cutout (adhered with Grafix double-tack adhesive film). Printing plates offer a lot of opportunity for mixed-media layering, look for them online or in local shops.

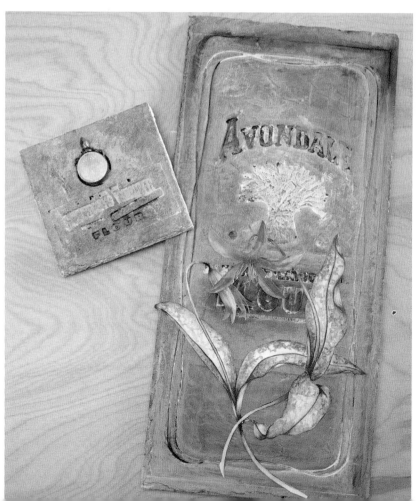

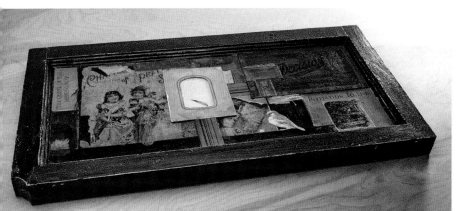

CABINET DOOR BEFORE AND AFTER

Because they are solid, cabinet doors provide the perfect surface for mixed media. I choose this door because it was recessed and would hold my embellishments perfectly. My first step was to paint the outer frame with GAC black gesso. Next, I adhered vintage book covers, cigar box lids, vintage paper frames and other ephemeral pieces with Beacon 3-in-1 Advance Glue, embellished with GAC acrylic paint and graphite. It was distressed with sandpaper and coated with a layer of GAC self-leveling clear gel before application a top coat of GAC polymer varnish with UVLS in a satin finish.

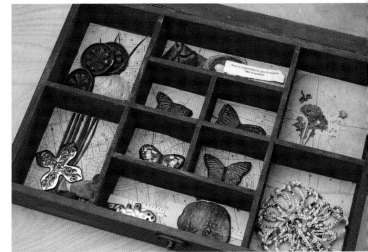

CURIOSITY BOXES

Try creating mixed-media pieces out of shallow boxes, frames, trays or other items. I refer to these as curiosity boxes and fill them with objects of my interest. This may be anything from a rock I found on a walk or a small piece of art. Either way, it is an attractive way to display items of curiosity or sentimental value.

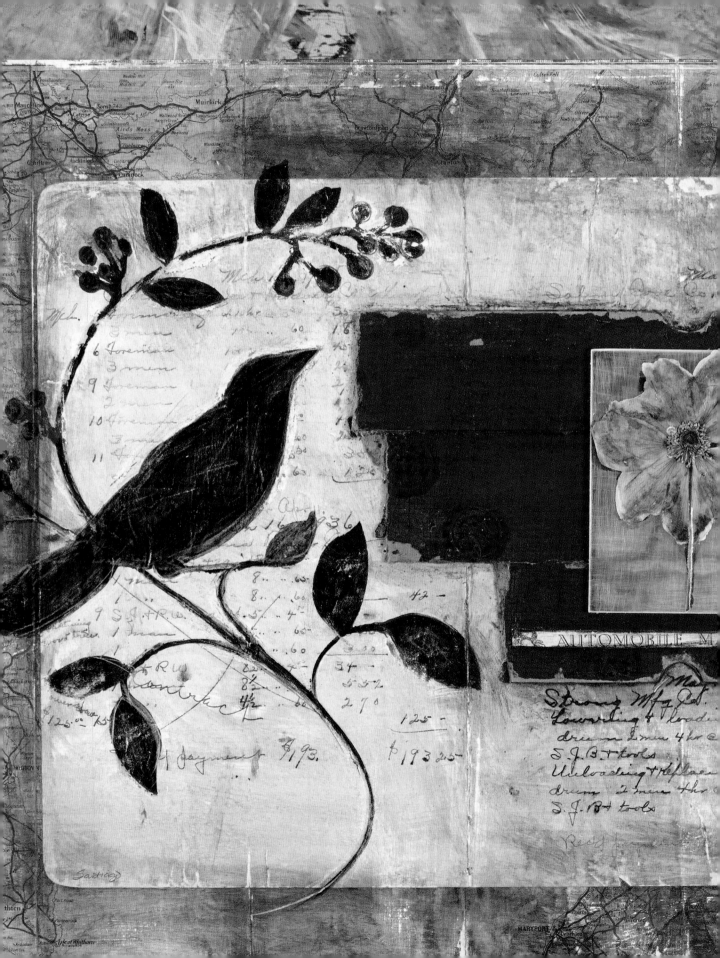

CHAPTER TWO
COMMITMENT

Adhesives, Tapes & Mediums

Adhesives primarily come in three forms: wet, dry and spray. Wet adhesives are exactly what they sound like, wet or liquid. This includes different products such as glues, mediums and pasted. Dry adhesives include tapes, double-tack sheets, dry-mount sheets, Velcro and putty. Spray adhesives are commonly found in aerosol cans.

Choosing the right adhesive for an intended application involves more than reading a few specifications on a data sheet. Adhesive selection is perhaps best viewed as both an art and a science; selecting the best formula for the job involves balancing many properties. For example, bond strength, flexibility, temperature resistance and ease of application are just a few of the many qualities to consider when selecting an adhesive.

Perhaps the most important consideration when choosing adhesives is the type of materials you are using in your piece. There are specialty items you can look for when buying adhesives, such as glue made especially for wood or fabric. Basic craft glue (or Aleene's Original Tacky Glue) should work on most materials, but for best results try to find a glue that is specifically formulated for your materials of choice.

Some adhesives will cover a wide range of projects, while others are less versatile. There are many different ways of applying adhesives: spray, brush, roll-on, squeeze tube, hot glue, etc. You might need a variety of different adhesives, depending on the artwork and materials. When deciding on your adhesives, consider the following basic questions:

- What is the drying time of the adhesive? Does it dry clear?
- How heavy are your materials? Will the adhesive hold the weight?
- Does the adhesive need to be removable or repositionable?
- How does the adhesive apply? Is it toxic? Do you need special ventilation?

The importance of each of these qualities can be thought of on a continuum in which certain properties are of critical importance to the application, and others are of lesser concern.

⚒ DRY ADHESIVES

Dry adhesives include tapes, double-tack adhesive film, dry-mount sheets, fusible webbing or iron-on interfacing, Velcro® and putty. There are several unique qualities that make using dry adhesives a good choice. The market has several fine manufacturers of these products, resulting in easy availability and reasonable expense. Dry adhesives are clean with no fumes or liquid mess. The dry time is instant with virtually no wait. The disadvantages are that dry adhesives are used mostly for two-dimensional flat surfaces and they are not repositionable and cannot be removed.

FILM

Double-tack adhesive film is available in different sizes, has high quality easy-to-peel silicon liners on both sides, and is an acid-free non-yellowing adhesive approved for indoor and outdoor use. It is a permanent, strong adhesive for heavy papers.

Dry-mount film is an advanced and professional method of adhering artwork. StudioTac dry adhesive from Letraset is equally as strong and effective as other types of adhesive products. It is a clean and easy-to-use product for adhering lightweight materials to your art. I like to use StudioTac because it does not gum up most computer equipment. StudioTac creates a strong, secure bond and enables you to reposition the elements of your artwork easily without tearing. It is fume and vapor-free, won't stain or curl fine papers and has archival quality.

Putty may be the perfect adhesive for a couple of different situations. Putty can be a substitute for tacks, tapes, staples and pastes; it fastens items to most nonporous flat surfaces. It is reusable, removable and lasts indefinitely. Putty is also moldable to help anchor collectibles onto surfaces. Secondly, because I like to view my work in process in a hanging position (and not flat on my work table) I use putty to temporarily position collage elements.

TAPE

The beauty of this particular adhesive is that it can be used in a variety of ways. Whether you are looking to use tape as an adhesive or as a decorative element, tape is a material that is generally inexpensive. Keep in mind that most tapes are not repositionable. In other words, once the tape is positioned on the artwork, removing it may not be possible. The tape

may also leave an adhesive residue behind, tear or destroy the surface of the art. I advise you to test your tape on a throw away material before applying it to your artwork.

ArtEmboss Metal Foil Tape adds a metal edge or strip to your project. Its strong adhesive bonds to most any clean surface. This decorative tape can be embossed with a fine point stylus to add pattern or texture to your design.

Artists' tape is a type of masking tape that is non-staining, repositionable and usually made from craft paper. It comes in various colors and is designed to be used on surfaces like canvas, paper and more. Because it bonds firmly it can yield hard paint lines.

Chart Tape (by Utrecht) is used for making lines on charts, dry erase boards and maps. It's a repositionable, clean removal adhesive system that leaves no residue. I have used it in many mixed-media projects (sealed with a varnish or medium). It is available in different widths and designs, and it adds a graphic element and looks striking.

Double-sided tape simply refers to the adhesive on both sides. This is available in a range of tapes: Double-sided tape can be used in a variety of applications such as temporary holding and splicing, mounting, bonding, or as a permanent adhesive.

Duct tape is available in different designs and colors and ranges from economy-grade to premium-grade. It suits the needs of almost every application. Duct tape is universally known as the ultimate tape to fix just about anything and it has good adhesion characteristics. Most general use applica-

tions are packaging, bundling, sealing, seaming, repairing, holding and waterproofing. Duct tapes have a high tack adhesive and superior shear performance that grabs quickly and seals dependably. With a more cloth-like appearance, duct tape can be used in bookbinding. Duct tape can also be used in fashion, craft, art projects and more.

Electrical or vinyl tapes are available in different grades. There are inexpensive electrical tapes to the higher grade tapes, which include all-weather grades. Some are even available in a variety of colors. These tapes are flexible and durable.

Foam tape is usually two-sided and used in the service industry for insulation around windows and doors. Foam tape is used in mixed-media to adhere materials or objects that need lift from the surface.

Foil tapes can be aluminum, copper or lead. Its true applications are in the HVAC industry. However, these tapes are quite beautiful and can add a textural element to your art or craft project.

Masking tape is an adhesive available in many widths and under different names, such as drafting tape, framers tape and artists tape. The major difference in these products are the strength of the adhesive or tack.

Painter's tape is a safe-release tape that I use to hold or mask areas on the artwork. This tape was designed as a protector for interior and exterior painters. It is UV and sunlight resistant and can be easily removed for up to fourteen days following application.

Vinyl tape (most commonly known as electrical tape) is resistant to acids, alkalides, oils, moisture, humidity, corrosion and UV light. A variety of colors are available.

Washi tape has become a popular material in mixed-media projects because of its versatility. These masking tapes are made of *washi* or rice paper, so they are semi-transparent, have a nice feel and are easy to use. Washi tape can be reused since it is removable and repositionable. It is available in a plethora of colors and designs.

Transparent Tape

Invisible tape and non-glare tape are both suitable for applications in which you want the surface beneath to show through.

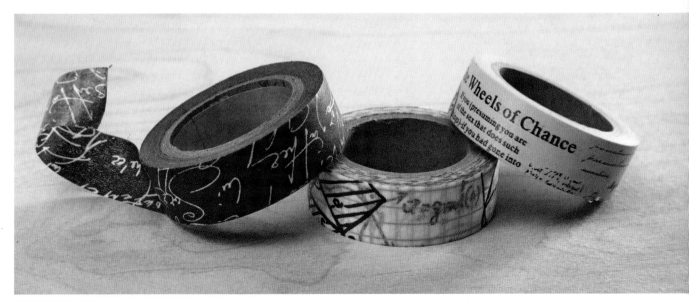

WASHI TAPE

Double-Tack Adhesive | *Follow the steps to adhere collage materials with double-tack adhesive.*

MATERIALS collage image craft knife double-tack sheet scissors

1 APPLY THE COLLAGE MATERIAL TO THE DOUBLE-TACK

Cut around the general shape of the collage image. Peel back the top layer of the double-tack sheet. Lay the collage material onto the double-tack. Press down and smooth it out with your hand.

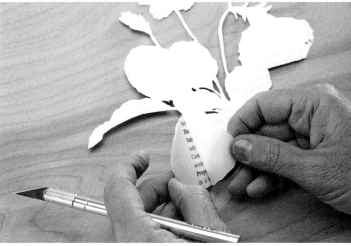

2 CUT AND PEEL

Cut out the detailed piece. Use a craft knife to help pull the other side of backing off. Pull only about half of the backing off at this point.

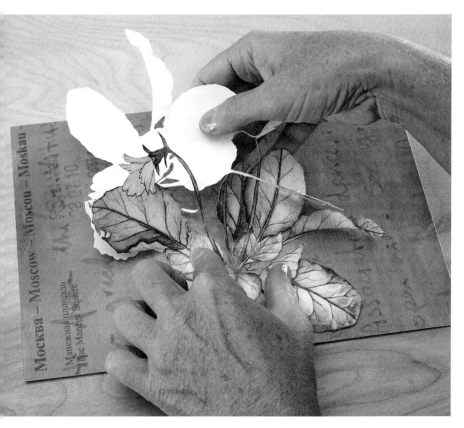

3 ADHERE THE COLLAGE MATERIAL TO THE SUBSTRATE

Adhere the unpeeled part of the image to the surface. Then pull the rest of the backing off and continue adhering the collage to the surface.

SPRAY ADHESIVES

Spray adhesives offer great coverage and strength, and dry fast and clear. Most spray adhesives are acid-free and archival, and they come in different weights or strengths. An extra-strength formula will be strong enough to adhere plastics.

Depending on your application, most spray adhesives can also be repositionable. Some offer an extended open-tack time. (Be sure to check the label.) This means that you can adhere with a lightweight spray that allows you to reposition materials. If a heavier spray is applied, however, it becomes permanent and unmovable.

One of the main disadvantages to spray adhesive is the strong odor. In addition, aerosol sprays are not as easy to control as other adhesive methods. Some aerosol sprays may leave a slight texture (webbing) on the materials, and sometimes it can be difficult to see where the adhesive has been applied. Keep in mind that spray adhesives are not washable, and may cause some materials to curl. You will need to allow twenty-four hours drying time before adding other wet mediums to the surface.

Adhesive spray is formulated for mounting items to a variety of surfaces, including plastics. It dries clear and relatively quickly, is nonwashable, acid-free, archival and has a no-wrinkle bond. Good for:

- Light to heavy paper materials
- Some textiles
- A variety of substrates, porous and nonporous
- Dry mediums within minutes of application

Best-Test acid-free adhesive spray is a non-yellowing, super strong adhesive that can be used with a wide range of materials, including plastics, foils and fabrics. It dries clear and relatively quickly, is nonwashable, acid-free, archival and has a no-wrinkle bond. It is repositionable up to five minutes before fully dry. Good for:

- Light to heavy paper materials
- Some textiles, foils, cardboard and delicate artwork
- A variety of substrates, porous and nonporous
- Dry mediums within minutes of application

E6000 Spray Adhesive has no odor, is nonaerosol, has minimal overspray, and cleans up easily with water. Good for:

- Light to medium materials
- Acrylics, paper, cardboard, fabric, felt, wood, metal, rubber and paper surfaces
- A variety of substrates, porous and nonporous
- Dry mediums within minutes of application

General purpose mist spray adhesive is a versatile, high performance adhesive for use in packaging, lightweight bonding and fabricating, labeling, and shipping applications. It can produce permanent and temporary bonds. The nonstaining formula is perfect for bonding acrylics, paper, cardboard, fabric, felt, wood, metal, rubber and paper surfaces. It does not contain chlorinated solvents. Good for:

- Light to heavy materials
- Acrylics, paper, cardboard, fabric, felt, wood, metal, rubber and paper surfaces
- A variety of substrates, porous and nonporous
- Dry mediums within minutes of application

Hi-Strength spray adhesive is fast-acting with a variable-volume web spray pattern that has high contact strength. The webbing pattern lets you see the amount of spray that has be applied to the materials. However, the webbing may also leave a slight texture on the materials. It dries clear and relatively quickly, is nonwashable, acid-free and archival. Good for:

- Light to heavy paper materials
- Some textiles
- A variety of substrates, porous and nonporous
- Dry mediums within minutes of application

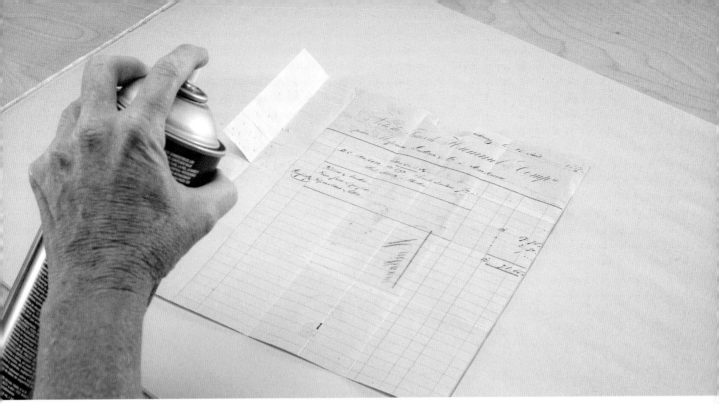

Spray adhesive is applied to collage materials at a 45° angle.

Low-Odor Spray Glue has a low-odor formula, making it convenient to use indoors. It also offers an extended drying time, which permits easy repositioning before the adhesive becomes permanent. It dries clear, is nonwashable, acid-free and archival. Remember that low-odor spray glues are for single layers only. Additional layering of paper or photos may not adhere properly. Allow the glue to dry for twenty-four hours before adding other wet mediums to the surface. Good for:

- Light to heavy paper materials
- A variety of substrates, porous and nonporous

Mounting spray is repositionable and will stick and re-stick repeatedly. It provides a light tack in seconds and dries clear. It is nonwashable, acid-free and archival. This adhesive is meant to be used for single layers only. Additional layering of paper or photos will not adhere properly. Wet mediums are not recommended with this adhesive. Good for:

- Light to medium paper, materials and photos
- Presentation board (may be used again in other projects)
- A variety of substrates, porous and nonporous
- Temporary installations
- Dry mediums within minutes of application

Multi-purpose adhesive spray is specially formulated for mounting items to a variety of surfaces, including plastics. It dries fast and clear and sprays wide to cover large areas. It is nonwashable, acid-free and archival. Multi-purpose adhesive sprays are for single layers only. Additional layering of paper or photos may not adhere properly. Allow twenty-four hours before adding other mediums to the surface. Good for:

- A variety of surfaces including plastics
- A variety of substrates, porous and nonporous
- Dry mediums within minutes of application

Permanent spray adhesive may or may not be repositionable depending on the application of the spray. In other words, if you apply a light coat, it should remain tacky. This will allow you to reposition the materials. However, if you apply a heavier coat, the tack time is narrowed and the material will become permanent. It dries clear, is nonwashable, acid-free and archival. This adhesive is for single layers only. Additional layering of paper or photos will not adhere properly. Wet mediums are not recommended. Good for:

- Light to medium paper materials and photos
- Presentation board (may be used again in other projects.)
- A variety of substrates, porous and nonporous
- Temporary installations
- Dry mediums within minutes of application

Photo mount spray adhesive is identical to mounting spray. A repositionable mounting spray that will stick and restick. It provides a light tack in seconds and dries clear. It is nonwashable, acid-free and archival. This adhesive is for single layers only. Additional layering of paper or photos will not adhere properly. Wet mediums are not recommended. Good for:

- Light to medium paper materials and photos
- Presentation board (may be used again in other projects.)
- A variety of substrates, porous and nonporous
- Temporary installations
- Dry mediums within minutes of application

Repositionable spray adhesive is similar to mounting spray. This adhesive will stick and restick. It provides a light tack in seconds and dries clear. It is nonwashable, acid-free and archival. This adhesive is for single layers only. Additional layering of paper or photos will not adhere properly. Wet mediums are not recommended. Good for:

- Light paper materials and photos
- Presentation board (may be used again in other projects.)
- A variety of substrates, porous and nonporous

A Word of Caution!

Always make sure to use spray adhesives in a well ventilated area! Some adhesive sprays are available in a low-odor formula for indoor convenience, however, there are still risks involved. Also be aware of the potential for allergies, asthma and skin reactions when working with spray adhesives.

- Temporary installations
- Dry mediums within minutes of application

Spray adhesive for Styrofoam allows you to glue Styrofoam to Styrofoam or to other materials like fabrics, ribbons, cardboard, paper, sequins and wood. This is a heavy duty spray and not repositionable. It is also nonwashable, acid-free and archival. Wet mediums are not recommended. Good for:

- Styrofoam, fabric, ribbons, cardboard, paper (light to heavy) and wood
- Presentation board (may be used again in other projects)
- A variety of substrates, all porous

Super Quick Grip Spray Adhesive is a fast-acting adhesive for lightweight surfaces. It adheres in seconds and dries strong and permanent. It creates a smooth, flexible, non-wrinkling bond. This adhesive is for single layers only. Additional layering of paper or photos will not adhere properly. Wet mediums are not recommended. Good for:

- Lightweight surfaces
- A variety of substrates, porous and nonporous
- Dry mediums within minutes of application

Adhesive remover quickly and effectively removes adhesive and other difficult-to-remove materials. It eliminates adhesive residue left by spray adhesives, stickers, tape and more. It will be dry to touch and handle after wiping the surface. Good for:

- Metal, plastic, glass, nonporous surfaces, most paintable surfaces and sealed ceramics
- Removing crayon, marker, grease, oil, wax and paint overspray

Adhering With Spray Adhesive

Follow the steps for adhering mixed-media materials to a substrate using spray adhesive.

MATERIALS collage materials spray adhesive tweezers (optional)

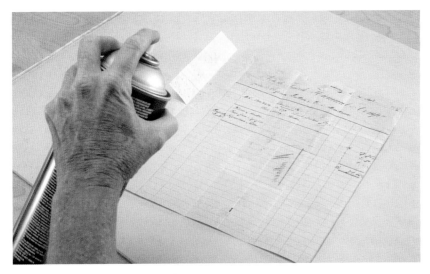

1 BEGIN APPLYING ADHESIVE

Place the item face down on a clean support. If the item is lightweight and easily movable, secure it with a straight pin or small weight, such as a coin. Apply the spray evenly by holding the can at a 45° angle and 12"–18" away from the surface. Spray an even coat over the entire surface, do not overcoat (heavy layers of spray doesn't ensure adhesive qualities).

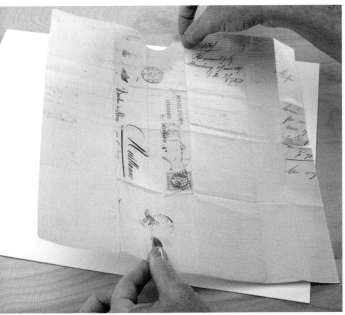

2 PLACE THE COLLAGE ITEM

Gently pick up the item with your index finger and thumb. You may choose to use tweezers to keep your hands from getting sticky. Hold the collage item over the desired area before releasing to help position correctly on the surface. Gently sag the paper to release the mid section onto the surface.

3 SECURE AND SMOOTH OUT

Continue to release the edges and smooth down with the palms of your hands, working from the center out to the edges.

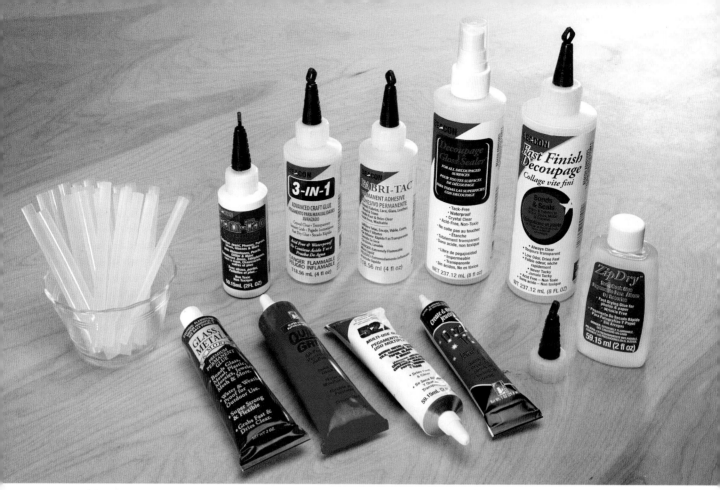

GLUE IS AVAILABLE IN MANY FORMS AND APPLICATIONS

🔥 WET ADHESIVES

Wet adhesives are usually in containers that have easy application and control. They come in different applicators for specific projects and accurate application. Most wet adhesives are acid-free, archival and permanent. Different strengths of wet adhesives are available, and they may all be used indoors, are water-soluble, clear-drying and easy to clean up. Some wet adhesives (mediums) may also be used as a sealer.

Some of the disadvantages of wet adhesives are that they may not be water resistant, the drying times may vary, and they may create texture in the materials, such as bubbles or wrinkles.

GLUE
There are a variety of glues available. While many glue materials are the same in content, they are different in application or form. When considering a glue for your adhesive needs, think about the application process, the type of materials and substrate.

Contact cement is an instant permanent water resistant bond for tile, wood, metals, leather and rubber. Contact Cement is Neoprene rubber for an ultra flexible bond. It is permanent—so planning is important.

Fabric glues eliminate the task of stitching and pinning. Check out basting glues and other textile glues to see what works for your projects. Stop Fray or Fray Check is used as a finish for fabric edges, seams, ribbons and lace. If you are in need of a fabric stiffener, Aleene's Fabric Stiffener is a permanent pre-mixed and water-based glue that is easy to use in one application and humidity resistant. Dries quickly to a clear, non-yellowing finish.

Glue Dots can be used for adhering materials like buttons. Glue Dots are available in many different sizes and application processes. They are acid-free, photo safe, mess free and easy to use. They are doubled sided adhesives that bond instantly to any surface and are available in permanent and removable formulas.

Glue pens are great for adhering small and delicate pieces. The sleek Pen shape offers control for a precise application. The glue is acid-free, bonds clear and strong and will not yellow or damage your materials.

Glue sticks go on smooth and dry fast and clear. Manufacturers produce glue sticks in colors to make it easy to see where the glue has been applied. Most glue sticks work on a variety of paper types including cardboard, form board, display board, computer paper and more. Glue sticks are washable, acid-free, photo safe and non-toxic. I like to use glue sticks in my mixed-media projects on paper edges or frays due to sanding. A glue stick is easy to apply under small corners and results are great.

Goop adhesive glue is an adhesive and sealant that is waterproof. It works well with rhinestones, ribbons, buttons, clothing ceramics and fabric. It is washer/dryer safe for embellishing fabric.

Hot glue guns are available in different temperatures. Low temperatures glue guns are good for bonding delicate materials such as lace, foil ribbon, floral foam and lightweight fabric. High temperature glue guns will bond nonporous materials, such as metal, plastic, magnets, ceramics, wood and glass. Be cautious and take care when using a glue gun.

Mod Podge is a water-based adhesive designed for decoupaging paper or fabric to many surfaces. It is available in gloss or matte finish. Aleene's Instant Decoupage is a similar product.

Paste is similar to glue but contains fillers (flour, marble dust, paper flakes, etc.). These fillers give the paste its consistency. Any of a range of thick adhesives, including white paste and wallpaper paste are a mixture of water, starch and such fillers. Original Yes! Paste is non-toxic and acid-free.

Permanent glue covers a base of different strengths and properties. Look for the type of permanent glue that best suits your project needs. Electric UV 6800 and E-6000 have superior properties. UV-6800 is enhanced with UV stabilizers, which provide ultraviolet resistance for marine and outdoor applications. UV-6800 may be used as an adhesive on fiberglass, concrete, metal, glass and wood, including specialty woods like teak. Super Glue is formulated for any nonporous material and has excellent bonding qualities. Platinum Bond by Beacon has amazing bonding powers for gluing glass beads and acrylic beads to nonporous or slick surfaces.

Rubber cement is an economical product that is easy to use. It is available in cans or bottles and comes with a brush applicator. Rubber cement dries clear is easily remove with a rubber cement pick-up eraser. Simply rub the dried excess rubber cement and it will peel off. Turpentine or a turpentine alternative (such as Best-Klean) is for thinning or reducing rubber cement. Use only in a well ventilated space and beware of allergies. Rubber cement sticks paper to paper quickly and without wrinkling. Papers can be pulled apart and repositioned. Note that rubber cement is not acid-free and will yellow and breakdown over time.

School glue or white glue is the glue we're all typically familiar with. It is economical, non-staining and transparent when dry; it is used for all porous and most nonporous materials including paper, wood, glass, cloth or tile. It is nontoxic, washable and safe to handle.

Specialty glues can be a life saver. Companies like Beacon Adhesives have provided the market with numerous solutions for mixed-media artists. Finding the right adhesive is imperative when adhering unique materials. Take the time to look at which specialty glue will work best for your project. Consider the following options when choosing a specialty glue:

- **3-in-1 Advanced Craft Glue.** Use for ceramics, fabric, glitter, leather, papers, stones and wood.
- **Beacon 527.** Use for canvas, cardboard, ceramics, glass, jewelry findings, leather, metal, wire and wood.
- **Bead Enhance.** Use for beads and jewelry findings.
- **CraftFoam Glue, Foam-Tac and Hold the Foam.** Great for anything with foam.
- **Dry Clean Only Adhesive.** If you are working with textile and need an adhesive that is nonremovable and will stand up to strong dry cleaning solvents, this is it. It is permanent and strong.
- **Fabri-Tac w**orks with a wide range of porous materials like canvas, cardboard, fabrics, leather, papers, photos and wood. It even works on beads and gems. Felt Glue is a strong and fast grab for fabrics and glitter. Liquid Thread is described as a "sewing machine in a bottle." It also can withstand dry cleaning solvents.
- **Ornament glue is a** great glue for beads, gems and glitter. It adheres nicely to metal and stone.
- **Super Glue is f**ormulated for nonporous materials and has excellent bonding qualities.
- **Tacky glue.** Super thick tacky glue can be used in place of hot glue. It's especially good for fabric and paper, and can be thinned with water or thickened by freezing. It's easy to clean up and non-toxic.
- **Wood glue.** A fast-drying, super strong glue that can be sanded. It sets fast, leaving a natural stainable or paintable color. Use on both soft and hard wood surfaces. It is water-based for easy clean up and recommended for any mixed-media project involving wood.
- **Zip Dry.** A fast-drying, multiuse (for most porous surfaces) glue that is also nonwrinkling.

MEDIUMS

It is important to note that the word "medium" has several meanings when referring to art. In this section, we are discussing mediums as adhesives to bind an element to a substrate in a mixed-media artwork.

Mediums can be a bit confusing because they have several uses and come in different formulas and viscosities (thicknesses). For instance, you will find low viscosity (liquid) and high viscosity (paste or gel) mediums. Both are equally good—the choice is a matter of application, use and amount of texture. Pastes and gels may be manipulated to a greater degree of texture.

Gels range from soft to extra heavy. The softer or more pourable the gel, the slighter the peaks. Purchase the strength you are looking for in your artwork. If you want a stronger hold, use a heavier gel. Mix the gel with acrylic paint for glazing or other techniques where transparency is desired. Use as a nonremovable isolation coat, applied over the painting and before the varnish (be sure to thin with water: 2 parts gel to 1 part water). Gels are also recommended for collaging.

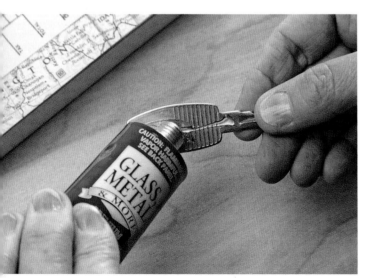 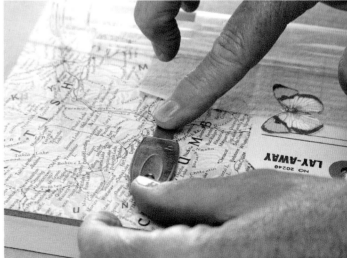

DIFFICULT ADHESIVES
Use Beacon premium permanent glue for adhering glass and metal to substrates.

The major difference between a pastes and gels is the opacity. Pastes can contain ingredients like a marble fill or fiber, which alters the effects of pigments or color. Gels are more clear and do not effect the color of paint. A good rule of thumb is the clearer the medium, the truer the pigment or color. Along those same lines, the clearer the medium, the more adhesive strength it will have.

Varnishes differ mostly in that they are not porous. They are exceptional for top coats and highlighting. They are made to seal and protect artwork. They can also be professionally removed without damaging artwork—a plus for any work that needs restoration. Varnishes are available in different finishes. A matte finish is flat, satin has a low sheen, and gloss finish has a high sheen (shiny).

Glazes are similar to mediums and typically, are transparent liquids that dry with a sheen. Glazes can also be used to seal and protect projects and slow down drying time to allow for manipulation and finishes. They can highlight an area in artwork or pull out an element within mixed-media art. Glazes dry clear but may have sheen or shine. They are available in different finishes and colors. (Polymer mediums are not available in color.)

Acrylic polymer mediums were developed to help artists extend the life and quality of their paints. Golden Artist Colors has a nice range of acrylic polymer mediums ranging from GAC 100 to GAC 900. These specialty mediums can be blended with acrylic paints to extend the paint, regulate transparency, create glazes, increase gloss, reduce viscosity or improve adhesion and film integrity. Another great characteristic about these mediums is their binding quality. The GAC polymers can be used for binding pigment solids for various effects and surfaces. For example GAC 900 is a liquid acrylic polymer designed to be used on textiles. This product can be blended with various acrylic colors to produce fabric paints that can be applied with airbrush, screened or painted by hand.

Acrylic Gel 531 is a Grumbacher product, designed to make opaque products more transparent and increase the transparency of semi-transparent acrylic colors while maintaining the consistency of the true tube color.

Acrylic modeling paste is compounded with ground marble; dries and hardens rapidly, becoming tough, resilient and durable; You can model, shape or texturize this paste while wet, and carve, cut or sand when dry. When mixed with acrylic colors, viscosity increases, making the colors more translucent and matte. Liquitex offers a Light Modeling Paste that has similar qualities but is designed to be lighter in weight.

Acrylic varnishes mix with color to increase adhesion, water-resistance and gloss. Use a crystal-clear, final coat for acrylic paintings or mixed-media (test product on your materials before using on art). You may also use this as adhesive for collaging paper and 3-D objects. This varnish has a good strength and is recommended for use with light to medium weight objects or papers.

Airbrush medium is pre-reduced and pre-filtered for use with airbrushes. Use it instead of water to thin acrylic paint. It maintains high quality color and will help extend the volume of your paint.

Blended Fibers texture gel is a Liquitex product with medium viscosity and semigloss sheen that adds a fibrous texture to acrylic paint.

Extra Heavy Gel is the thickest of GAC gels. It blends with colors to increase body, is excellent for holding peaks and impasto techniques, and it dries translucent. It comes in different finishes, such as gloss, matte, semigloss and molding paste.

Fabric medium does exactly what it is states: enhances workability of acrylic paint on fabric. Mixed with acrylic paint, you can easily paint on fabric.

Flow Aid is a flow-enhancer medium by Liquitex that can be mixed with any water-soluble paint, medium ink or dye to break down water film tension, allowing better absorption into a painted surface. It has a more even application when working on nonporous surfaces and it helps to achieve deeper stains, smoother flow through airbrush application, and covers larger flat areas of smooth color.

Gloss and matte gel mediums by Liquitex have a very high density and produce extremely viscous and oil-like drag. Gel mediums will give you more volume of paint with little extra cost. They can be mixed at a 50/50 ratio without changing

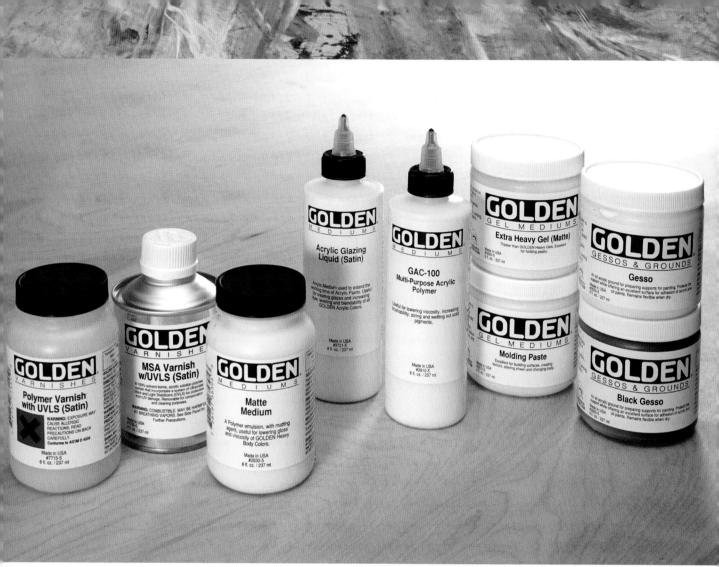

MEDIUMS INCLUDE VARNISHES, GLAZES, PASTES AND GELS

the color of your paint. If you dilute more than 50/50, the mediums will act as tinting white.

Glass Bead Gel is a translucent textural product that blends glass bead solids into acrylic medium. The reflective quality of the glass generates a luminous effect. It is similar to the reflective look of road signs. I love using this product in my mixed-media to add a pop of sparkle within the art.

High gloss varnish is a water-based permanent protective coating that can be applied over any acrylic paint or stain. This varnish can be sanded and is non-tacky when dry. It will not crack or yellow.

High Solid Gel is a GAC product with a thick consistency that holds peaks, blends with colors to make them feel more

oil-like, and increases the retention of brushstrokes. It offers lower shrinkage and dries to the touch quicker than most gels.

Matte medium is an acrylic medium useful for extending colors for economy, increasing translucency and decreasing gloss. It also increases film integrity when excessive pigment, filler solids or water is added. This medium is useful as a translucent ground and adhesive.

Matte varnish is to be used over acrylic paint as a final coat. Test it over your materials for mixed-media usage.

Natural Sand Effects texture gel by Liquitex is a product that has low viscosity, a glossy sheen, and a fine texture of sand. Mix with acrylic paint to add texture.

Pearlescent tinting medium gives a shimmery pearlescent metallic luster when mixed with pure acrylic color. Use it alone and it dries to an attractive off-white/pinkish pearlized color. It works well on both white surfaces and darker surfaces.

Polymer Medium is a general purpose liquid medium useful for creating glazes, extending colors, enhancing gloss and translucency and increasing film integrity. Polymer medium (Gloss) has a unique feel that is much more oil-like or resinous in nature and that promotes flow and leveling.

Pumice Gel will add texture to your acrylic paint. GAC offers three different finishes: fine, coarse and extra course. Use it to create texture; it dries to a hard film. You can increase the flexibility of Pumice Gel by mixing in other mediums or gels.

Self-Leveling Clear Gel is a GAC product designed to produce an even film with excellent clarity. The gel has a unique resinous consistency resulting from its self-leveling properties. It dries to a flexible, high gloss film, which can increase transparency and sheen. It blends with acrylic paint to produce glazes.

Silkscreen medium is a water-borne system designed to blend with acrylic paints for silk-screen application onto paper, wood and other suitable substrates. It is designed to increase working time and prevent paint from drying in the screen too quickly. This medium is not to be used on fabrics that will be laundered. You will need to use Silkscreen Fabric Gel if you are screening on fabrics that are going to be washed.

String Gel has the consistency of honey. Mixed with acrylic paint, it enhances color and increases the transparency and flow. It will dry in a gloss finish.

Polymer Varnish with ultraviolet light stabilizers (UVLS) is a waterborne acrylic polymer varnish from GAC that dries to a protective, flexible, dust-resistant surface over acrylic paint and mixed-media (test your materials). It is removable with ammonia and is available in three different finishes: gloss, satin and matte.

MSA varnish with UVLS is a mineral spirit acrylic-borne resin system. MSA varnishes are formulated to be a tougher, less permeable film than waterborne acrylic emulsion varnishes. MSA varnishes reduce dirt penetration and surface marring, offering an extremely level film with less foam and fewer pinholes. It is removable with turpentine post drying. It is available in different finishes: gloss, satin and matte.

Both polymer and MSA varnishes are recommended for acrylics, oils, pastels, temperas, watercolors and various other media. Remember to follow health labels and adhere to product instructions for all varnishes.

Are We Clear?

One of the most important things to keep in mind when buying wet adhesives for art or craft projects is whether or not the adhesive will dry clear. Even if you wipe away excess glue after constructing crafts, some will likely show in nooks and crevices or around edges. Most projects will turn out much better if you use craft glue that dries clear.

Adhering With Wet Adhesive | *Follow the steps for adhering mixed-media materials to a substrate using a wet adhesive.*

MATERIALS no. 8 flat brush 1" (2.5cm) plastic putty knife Golden Matte Medium
collage materials paper towel

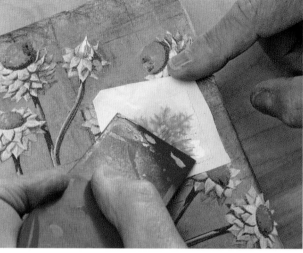

1 PREPARE THE COLLAGE MATERIAL
Brush Golden Matte Medium onto the back of your collage material using a no. 8 flat brush.

2 ADHERE TO THE SURFACE
Place the collage element onto the surface. Using the putty knife, press down gently and smooth out in one direction.

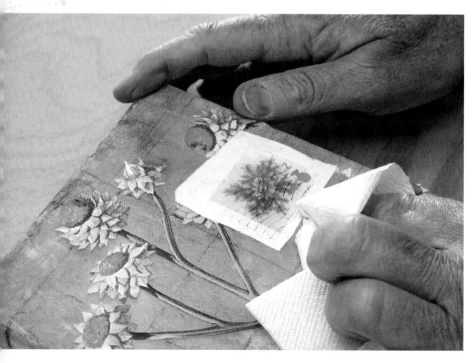

3 SMOOTH OUT
Use a paper towel to remove excess medium and to smooth out any wrinkles or bubbles.

Adhering Glass

Follow the steps for adhering difficult materials to a substrate using wet adhesive.

MATERIALS Beacon Glass, Metal & More Premium Permanent Glue glass collage elements

1 APPLY THE ADHESIVE
Apply a thin line of Beacon Premium Permanent Glue down the length of the glass. (In this case, a test tube.)

2 SECURE TO THE SUBSTRATE
Press the glass element down onto the substrate and hold it firmly in place for a few minutes to secure it to the surface.

Visit artistsnetwork.com/mixedmediahandbook to access bonus content.

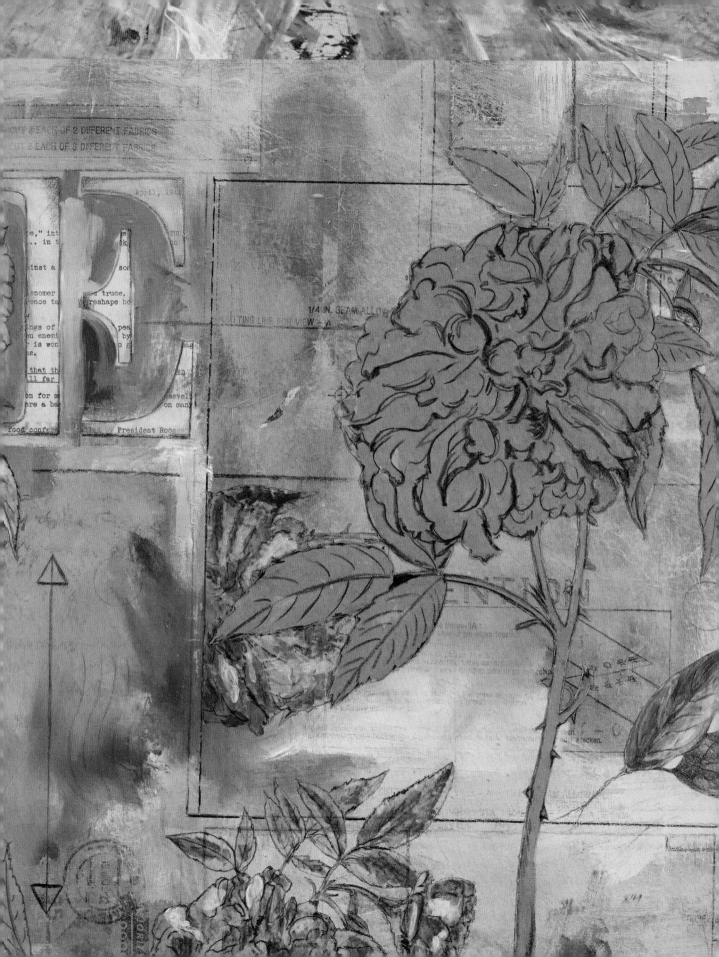

GETTING IT DONE

Mixed-Media Tools

Mixed-media art has a huge range of processes and techniques. Because of this, it is sometimes necessary to use tools and other household items in addition to the most commonly used artist tools. In this chapter we will focus on tools and how to use them when creating mixed-media artwork.

To help decide which tools to purchase for your projects, consider the following basic questions:

- Will the tool aid in the process and/or the look of the final outcome? For example, a craft knife or special blade would help with cutting and creating a polished, professional look to the finished artwork.
- Will you use the tool for other projects?
- Is it necessary to invest in replacement items with this tool? If so, and you plan on using the tool a lot, it may be best to buy the replacement items in large quantities.
- Is this a tool that can be shared? If so, consider splitting the cost with a fellow artist and sharing the tool.
- Do you have a place to store the tools?

CHOOSING TOOLS

Anodized aluminum plates are available in a range of sizes. These plates can be heated up and used just like a printing plate, cleaned up and used again. Enkaustikos registered products are designed for convenience and efficiency.

Awls are pen-like tools with a long needle-like metal tip. They are generally used for punching holes for bookbinding. You can use them to pierce paper or fabric. Be careful, they are sharp.

Bamboo skewers may not be regulation art tools, but they are quite handy to aid in scratch-out techniques, mixing paints or gluing down bits and pieces of paper.

Blades:
#10: slightly rounded tip, general cutting
#11: classic fine point; extremely sharp; fine-angle precision cutting and stripping
#15: keyhole saw blade for small spaces, designed for cutting plastic, balsa, cardboard, thin metals, soft foam and foam; performs like a tiny saw; available in different sizes; medium and extra fine for more intricate patterns
#16: scoring blade for stencils and etching
#17: lightweight wood chiseling blade

#18: heavyweight wood chiseling blade for deep cross and smooth chiseling of wood
#19: angled wood chiseling blades for deburring, chiseling and rough shaping
#22: large curved carving blade for shaping and whittling
#23: corner blade for angled cuts, close corners and stripping
#24: deburring blade for trimming, stripping, close corner cuts of templates and mats
#25: large contoured for heavy pressure of plastic, wood, linoleum, rubber and foam
#26: whittling blade for general whittling and trimming
#28: concave carving blades for whittling and curved shaping of balsa, leather, linoleum or plastic
Swivel blades: for circles and curves.

Blending stumps are similar to tortillons but are longer and have points at both ends. Blending stumps are used to blend strokes made by charcoal, Conté crayon, oil pastels, chalk pastels, pencil and more. When blending, hold the blending stump at an angle to increase the coverage area. The tip or end of the bleeding stump needs to be kept clean—especially light areas so as to not smear darker media unintentionally. Clean blending stumps by removing the used outer layer of paper with sandpaper (an emery board works great).

Left to right: hole punch, needle-nose pliers, X-tra Hands, staple gun and staples; Center: clips and tweezers

MEASURING DEVICES AND TEMPLATES

Left to right: French curve, slide rulers, angle rulers (triangles), flexible ruler, circle templates

Bone folders or scorers are used to score delicate fibers and papers. They resemble letter openers and are handy for the mixed-media artist. I often use my scorer to score a line so that I can tear it for a deckled edge.

Burnishers are usually two-sided tools similar to a writing pen. One end will have a small metal ball (various sizes available) and the other a flat plastic knife. This tool is used to aid in rubbing down and transferring decals, and blending or polishing colored pencils, wax pastels or graphites. One-sided burnishers resemble a butter knife—often found in a hard plastic.

Clips are usually referred to by the manufacturers' name Bulldog Clips. Clips come in different sizes and styles and are good for holding down substrates and papers.

Cotton swabs are inexpensive and versatile tools, They are great for blending graphite, charcoal, pastels, colored pencils and more.

Craft knives are blade handles that have replacement blades. The replacement blades come in different sizes, shapes and

weights, each with individual functions. The X-Acto knife from Elmers is a commonly used brand of craft knife with different styles of handles. The most common is the 4 ⅞" (12cm) aluminum handle. The blade package will specify which size handle to use. Replacement blade weights determine the amount of pressure that can be applied while cutting. If you are cutting thin paper, a light-duty blade will be sufficient; however if you are cutting a heavyweight paper or board, you'll need a medium-duty or heavy-duty blade. It is important to change the blade when it becomes dull or it will drag and tear. Remember to use a cutting mat underneath the material you are cutting. Properly dispose of blades to prevent injury. Be sure to store unused blades where they are clearly seen and easily reached.

Dremel rotary tools have a plethora of functions. This power tool is versatile, powerful and endlessly useful. It offers attachments for many different functions. You can sand, drill or saw with this handheld tool. Wear safety equipment when operating a Dremel.

Encaustic specialty tools, such as a wood-burning tool with different tips, are the key to working with encaustics. Encaustic hot tools include (but are not limited to) the metal pen point, angled brush tip, the bright brush tip, the angled flat brush tip, and the flat brush tip, which is available in different tip sizes.

Eyelet pliers are specially designed pliers that will insert eyelets into materials like fabric, leather and paper.

Grayscale value finders are small guides that help you mix color, tints or shades, find color schemes and more.

Heat guns will apply heat with the goal of extending the amount of time to work with a material or advancing the drying time. Always use caution when working with a heat gun.

Heat lamps basically serve the same purpose as a heat guns, however they are not quite as mobile. Use caution when working with a heat lamp.

Mitre boxes are boxes with different angled slits for cutting. They are meant to be used with a saw and blade for cutting angles and edges.

Mixing guides or color wheels will help in mixing paints. They are relatively inexpensive and tremendously helpful They come in different formats that can help determine value and intensity when mixing colors.

Nozzle tips are available for paint application from different manufacturers. Nozzle tips help make it easier to apply paints directly from the bottle or container.

Palette knives are manufactured in a variety of materials (plastic, wood and metal). They are also available in different sizes and shapes. Palette knives can be used to mix paint or apply it.

Paper trimmers are available with swing-arm blades or guided-hinge rail blades. Each type offers precision straight-edge cutting and trimming. Swing-arm blades include button released locking blade arm, cutting guide and gridded paper guide. Unlike the swing arm blade, the hinge-rail system is a replacement blade system.

Pastel holders are handy tools for holding pastels and keeping your hands and work surface clean. You only need one because they are hollow metal or plastic holders that fit over your pastels, allowing you to change pastels as needed.

Scissors come In many varieties.

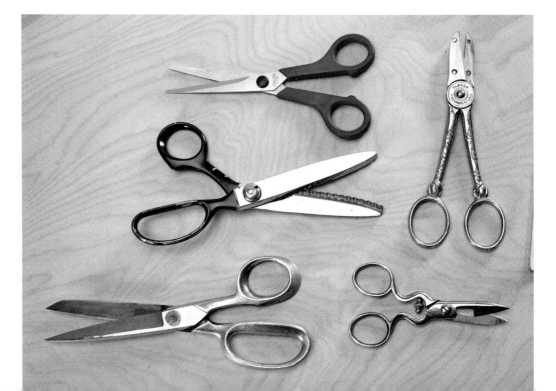

Plastic droppers or eye droppers are used for watercolor, color mixing, marbling techniques and more. They are relatively inexpensive and handy to have in your tool box.

Putty knives, like palette knives, are manufactured in a variety of materials (plastic and metal) and used for applying paint, burnishing down paper, collage techniques and more. They are also available in different sizes and shapes. I like to have a 1" (2.5cm) putty knife handy to help smooth down paper.

Rotary cutters are typically used by quilters to help expedite the cutting of fabric. This can be a quick and handy tool for cutting paper, too. Handheld rotary cutters a feature no-touch safety shield, blade replacement system, straight blades and pinking blades. I recommend using a self-healing cutting mat with the rotary cutter for efficiency and safety. Grid-lined mats are helpful with straight lines and measurements.

Rulers come in a range of types. Aluminum straight-edge rulers with cork backing work well with a craft knife for cutting or trimming the perfect edge. Wooden rulers with metal edges are also good for cutting or trimming. Transparent rulers are good to use over or on top of materials for measurements. T-square rulers will aid in squaring up measurements. The L-square ruler is an ideal tool for cropping artwork. Flexible rulers help establish curved lines. French curves, protractors, circle rulers and triangles are ideal for drawing shapes and curves. A compass is great for drawing circles. Circle templates are also an easy way to draw onto collage materials.

Sandpapers are useful in mixed media to help remove or expose different layers of the surface. They are also used for sanding and smoothing gesso and pigments. You can use sandpaper to create texture in paint. It is not a good idea to use sandpaper as a substrate because it is not a permanent paper and contains acid.

Scissors: There are several options that can aid in your mixed-media projects. A few features to consider are the weight of the scissor, composition of the scissor (stainless steel, plastic, titanium), corrosion resistance, ergonomic handles, nonstick surface, nonslip grip, antimicrobial grip, and optional spring action that keeps the scissor open and ready to cut until squeezed shut. The style of the scissor is dependent on the project and the person using them. Tips, blade sharpness, handle style and scissor size are important decisions for precision cutting and comfort. The tips may be blunt, rounded, flat, sharp or pointed. Electric scissors are a handy option, especially for cutting in large volumes. Black & Decker has a lightweight, rechargeable pair for a reasonable price.

Screwdrivers, especially the kind with inter-changeable tips are useful tools to keep around. They aid in framing and presentation. The flathead tip is also interchangeable as a burnisher.

Staple guns are traditionally used to help secure canvas to stretcher bars when stretching your own canvas. I also use a staple gun to adhere heavy two-dimensional papers, fabrics and other ephemera. Remember to use caution when working with a staple gun and wear safety goggles.

What Is Grit Size and What Does It Mean to Me?

The grit size of sandpaper refers to the actual size of the grit that is embedded in the paper. The number can sometimes be replaced with coarse, medium or fine, coarse being grit range 40-60 and used for heavy sanding and stripping; medium being grit range 80-120 and used for smoothing of the surface and removing small scratches or lines; and fine being grit range 150-180 and used for a final sanding pass before finishing or painting. There are extra fine grits ranging from 220-600 and these are generally used between coats of paint, for removing dust spots or blemishes.

Steel wool is available in the hardware store or art and craft store. Steel wool made for artists removes paint and ink without leaving behind an oily residue. Ampersand's oil-free steel wool is perfect for use on their products: Claybord and scratch board. Steel wool is used to create textures, tonal values and highlights. You can also remove surface pigments with steel wool. It comes in three degrees of grades; fine, medium and coarse.

Toothpicks are not your typical art tools, but they are quite handy to aid in scratch-out techniques, mixing paints or gluing down bits and pieces of paper.

Tortillons are similar to blending stumps, except they are tapered at the ends, made of rolled paper and are hollow. Not quite as long as blending stumps, tortillons create a different texture than blending stumps. Use them to blend strokes made by charcoal, Conté crayon, oil pastels, chalk pastels, pencil and more. When blending, hold the tortillon at an angle to increase the coverage area. The tip or end of the tortillon needs to be kept clean, especially light areas so as to not smear darker media unintentionally. This drawing tool will help with tight details and prevent oil residue from your fingers from getting into your art. Clean tortillons the same as blending stumps: remove the used outer layer of paper with sandpaper (an emery board works great).

Tweezers are helpful for picking up tiny and delicate materials. They are available in different sizes and styles. The tips may be blunt or angled. Select the size and shape appropriate for your needs.

Utility knives are sometimes referred to as box cutters. These knives come in a variety of styles and feature retractable and snap-off blades. Use this tool more for heavy-duty cutting and less for precision and details.

X-tra Hands is another tool by Elmers X-Acto. It features clips that hold materials so you can free up your hands while you work. It is available with or without a magnifier.

Cutting and Tearing Tips

- Prepare paper for a fold or tear by scoring it. Apply pressure to your paper with a ruler and then press a line into the paper using a scorer or bone folder. Once you have done this, the paper will fold with a nice crisp edge. If you are trying to tear or separate the paper, scoring it will give you a nice line. After you have made the score, place the folded edge on the edge or corner of a table and begin tearing.

- For precision cutting, always cut away from the angle or corner.

- For protection in cutting when using a ruler or guide, place the ruler where it protects the art or paper. This will insure that you do not pull or miscut into your art.

Securing Eyelets | *Add hardware embellishments to your mixed-media art.*

MATERIALS eyelet tool eyelets paper or fabric

1 SELECT THE EYELET
Plan ahead and secure the eyelets to a layer of paper or fabric before it is adhered to the substrate. Select the style and size of the eyelet, load onto the eyelet tool as directed by the manufacturer.

2 LINE IT UP
If you feel more comfortable with a guide, mark lightly with a pencil exactly where you want to place the eyelet. Line up the eyelet tool on the pencil mark.

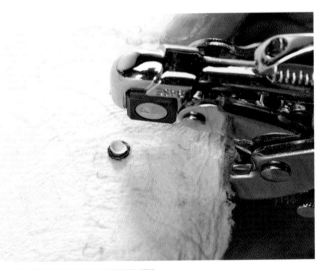

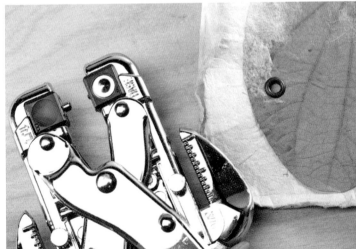

3 SECURE THE EYELET
Squeeze the handles of the eyelet tool tight without moving the position. Hold until you are confident the eyelet has penetrated the material.

4 CHECK THE EYELET
Move the tool slightly and check the eyelet. If you're satisfied, move the tool away completely. It may be necessary to push excess material through the hole in the eyelet. If the eyelet did not take completely, slide the tool back onto the eyelet and press more firmly. I recommend practicing with different materials before applying permanently to your art.

CHAPTER FOUR
EMBELLISH IT

Paper, Photographs & Other Collage Resources

I remember when I first discovered mixed-media art. It was an instant connection. The idea that I could use a mix of materials on my artwork was reassuring. As a traditional painter, I had always longed to add little snippets to my art. Once I saw that I could bend the rules and paste ephemera (or any other materials) directly onto the painting, my life as an artist took an entirely different direction.

A plethora of resources are available for the mixed-media artist. Collage materials may be purchased or found. You may choose to use a combination of materials or stay true to one. Art and craft stores have a range of collage resources to purchase, but really, you can find everything you need to create mixed media art within your home …

- Embellishments: beads, buttons, glitter, jewelry findings and textiles
- Ephemera: brochures, letters, playbills, postcards and tickets
- Paper: acetate, art paper, bond, construction, found paper, craft, reflective, Rub-onz transfer film, parchment, shrink film and vellum
- Photography: photo prints, slides and film

Regardless of your process, this chapter will leave you with a clearer understanding of where to source materials and how to use and create artwork with multiple materials. It will cover the most important characteristics to look for when selecting collage resources for projects and give you suggestions and ideas to further enhance your mixed-media art.

❧ EMBELLISHMENTS

Embellishing with traditional and nontraditional materials each have their own their challenges. This section explains and defines the application, along with the effect of adding glitz to your mixed-media projects.

BEADS

Beads are available in acrylic, glass, natural (shell, wood and nut), metal ,porcelain and pearls. While there are many additional kinds of beads, they generally fall into one of the above categories. Acrylic beads are economical, lightweight and a good alternative to glass. Natural, shell, wood and nut beads are beads made or produced from natural materials. These beads are sometimes be bleached.

If you are layering paint over beads, keep two things in mind: the type of paint and the type of bead. Acrylics and spray paints are usually an effective choice. Always test your materials before introducing them into your artwork

The following are some suggestions for adhering beads. Please note that some adhesives are specially formulated for glass beads, such as Platinum Bond and jewelry glue. It is important that you research the correct adhesive for your embellishment.

- **Goop adhesive glue.** Adhesive and sealant that is waterproof. Best for rhinestones, ribbons, buttons, clothing ceramics and fabric.
- **Contact cement.** Instant permanent water-resistant bond for tile, wood, metals, leather and rubber.
- **Super Glue.** For any nonporous material.
- **E-6000.** Best multi-surface glues.
- **Platinum Bond.** Amazing bonding powers for gluing glass beads and acrylic beads to nonporous or slick surfaces.
- **Jewelry glue.** Nontoxic washable glue for glass beads, rhinestones and mirrors.
- **Tacky glue.** A superior glue suitable for fabrics, paper and jewels.
- **Glue Dots.** Doubled-sided adhesives that bond instantly to any surface. Available in permanent and removable formulas. Mess free and easy to use.

ASSORTED EMBELLISHMENTS
Embellishments include beads, buttons, glitter, jewelry textiles and other "findings."

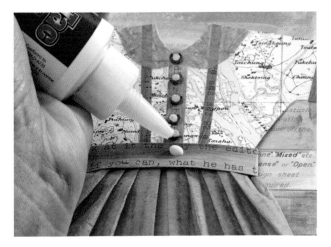

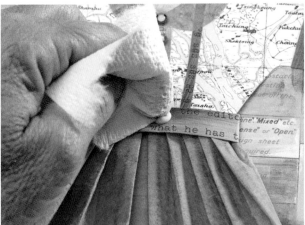

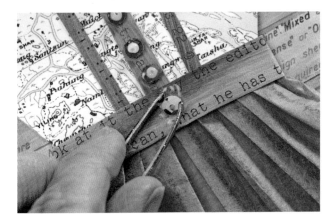

ADHERING BUTTONS WITH SPECIALTY GLUE

It may help to prepare the textured surface of a bead before gluing it to the substrate. Use an emery board or sanding swab to rough up the surface or sand it down. Apply the adhesive as directed and allow it to dry. Specialty glue, such as Tacky glue, works best for adhering this type of embellishment.

Tips for Working With Beads

- "AB finish" is a coating (usually on one side) applied to glass beads that creates a rainbow or iridescent effect. This effect was invented in 1955 by Swarovski in partnership with Christian Dior and was inspired by Northern Lights, called Aurora Borealis (AB). If you want to remove the AB finish from a bead, use fine steel wool and glass etching solution. Do not apply for a long period of time, or the surface will turn matte.

- Acrylic beads sometimes hold an odor. The best method for removing the odor without damaging the beads is simply to remove them from their packaging and allow them time to air out. If the beads are not painted and are without applied decorative embellishments, you can handwash them with gentle soap and water. Store them in a breathable bag or container with a fabric softener sheet.

- To reduce or stop the coating from flaking off a bead, apply a top coat of DesignaSeal or Vitrium Clear Protectant sealant. These products may be applied to gemstones, acrylic, glass and more. Do not coat natural pearls! Always test on one bead before applying a sealant to your entire supply.

BUTTONS

Buttons come in a variety of shapes, sizes and colors and are most commonly made of plastic. Vintage buttons can also be used for embellishing. Flat buttons are easier to adhere than shank buttons. Shank buttons have a hollow protrusion on the back through which thread is sewn. The shank maybe snipped out with wire cutters or needle-nose pliers.

The following are some suggestions for the best materials for adhering buttons. Also note that some buttons may be sewn on the artwork if preferred.

When layering paint over buttons, keep both the type of paint and type of button in mind. Acrylics and spray paints are usually an effective choice for buttons.

Paper may be collaged onto buttons as well. Use a dab of an adhesive from the list provided, or try a dry adhesive like double-sided tape or double-tack mounting film. Spray adhesives specially made for plastic surfaces are also a good choice. Test a few buttons before you begin your artwork. For plastic and wooden buttons use ...

- **Goop adhesive glue.** Adhesive and sealant that is water-proof. Rhinestones, ribbons, buttons, clothing ceramics and fabric.

- **Contact cement.** Instant permanent water-resistant bond for tile, wood, metals, leather and rubber.
- **Super glue.** Any nonporous material.
- **E-6000.** Best multi-surface glues.

For glass and bead buttons use ...

- **Platinum Bond.** Amazing bonding powers for gluing glass beads and acrylic beads to nonporous or slick surfaces.
- **Jewelry glue.** Nontoxic washable glue for glass beads, rhinestones and mirrors.
- **Tacky glue.** A superior glue suitable for fabrics, paper and jewels.
- **Glue Dots.** Doubled-sided adhesives that bond instantly to any surface. Available in permanent and removable formulas. Mess free and easy to use.

GLITTER

Glitter is available in loose form or as sprays. Spray glitter is great for a couple of reasons; it adheres the glitter as it sprays and it covers large areas quickly. The disadvantage is the it is harder to control. You must mask the areas that you do not want to have glitter.

ADHERING BUTTONS WITH GLUE DOTS

Glue Dots come in a different shapes and sizes and are a handy adhesive, especially for tiny items like the button I am applying in the photo. The advantage of using a Glue Dot in this situation is control: There will not be an excess of glue around the button to clean up. This eliminates the possibility of moving or disturbing the button before it completely dries.

Loose glitter is easy to use and you can control where you apply it. You must first, however, put down an adhesive. In this respect you have several choices: a spray adhesive (again, you must mask or cover areas not to be glittered); a wet adhesive like a glue stick works well and is easy to apply; or you can use a dry adhesive such as double sided tape or double-tack adhesive film. When you apply the dry adhesive, simply cut to size, adhere to the art and apply the glitter. Choose what is going to adhere best to your substrate and materials.

JEWELRY AND JEWELRY FINDINGS

Jewelry is defined just as you think. Jewelry findings are the chains, fasteners, jump rings and other supplies that crafts people use when making jewelry. Jewelry findings can be both interesting and functional for the mixed-media artist. Jewelry findings can be attached to substrates in a variety of ways (depending on the finding). You can sew, use an adhesive, or use hardware like clips, tacks or wire. Jewelry findings are inexpensive usually found in art and craft stores.

Jewelry, particularly vintage jewelry, has become popular in the genre of Steampunk style. This genre touches on a wide range of arts, literature, fashion and art. Many consider it a subgenre of science fiction and fantasy that includes aspects of the nineteenth century. But Steampunk has become a lot more. Steampunk is also a design aesthetic, with people "steampunking" everything from laptops and books to furniture and pianos.

TEXTILES

I have included fabric, ribbons, and thread into this category. Technical concerns for using textiles in mixed media are in the fabric itself. Most fabrics have a sizing and may need to be washed before being applied to a substrate.

Using textiles as embellishments requires a few considerations: the application of the textile; adhesive or sew on; the weight; and the structure. By structure I mean the shape or stiffness. Textiles may be stiffened by adding agents like fabric stiffeners or white glue. Beacon and Aleene's have products designed especially for this. It is always best to test a small swatch before applying a product to your entire piece of fabric. This is definitely true if you are considering a vintage fabric. This will also give you the opportunity to determine how stiff you want the fabric. You may lessen the degree of stiffness by adding water to most fabric stiffener products. Please read the label and follow the manufacturers' directions.

Ribbons and trims may be adhered with dry adhesives, like two-sided tapes. Once again, test and re-test to ensure success.

CONSIDERATIONS WHEN USING JEWELRY AS EMBELLISHMENTS
When using jewelry as an embellishment, consider the weight of the items, the substrate and application of adhesives.

EPHEMERA

Ephemera is defined as any transitory written or printed matter not meant to be retained or preserved, such as brochures, letters, playbills, postcards, tickets, catalogues, greeting cards, etc. Ephemera are typically the most used collage resource for mixed-media artists for a few reasons: They are easily available, inexpensive and usually relate a personal context within the artwork. The simple lines of handwritten letters or cards may bring artistic qualities. Vintage ephemera can be quirky or meaningful in the typeset alone. Because I view ephemera as personal value and individualism, they are represented frequently in the content of my mixed media.

When using ephemera, decide whether you want to use the original or a copy. This decision may be based on the condition of the ephemera. For example, perhaps it is frail and cannot withstand an application process. Or perhaps the value (personal or monetary) precludes use of the original item. In most cases, ephemera can be scanned or copied to crate an almost perfect duplication. It is sometimes a good idea to duplicate the ephemera for uses on other pieces or for reference. Duplicates are also helpful for determining composition and testing adhesive materials.

When layering paint and other mediums onto ephemera, consider the surface of the material. The more porous the surface, the more accepting it will be of paint. You can also lightly sand a slick or nonporous surface to get it to grab the paint better. There are additives to paint that will help with the binding process (see Chapter Two). The same is true for other embellishment processes or applications, such as pastels, pencil and markers. Be sure to always test and experiment.

EPHEMERA SOURCES
Sources for ephemera include clothing labels, calendar pages, flyers, envelopes, greeting cards, brochures and postage stamps.

POSTCARDS

The basic rule of thumb is to duplicate ephemera for the sake of putting it on an archival paper. This will also ensure longevity and successful application of adhesive. Speaking of adhesives, for vintage ephemera I recommend Grafix double-tack film. Wet adhesives that normally work well are mediums and gels (see Chapter Two).

VINTAGE LEDGERS

Vintage ledgers can easily be found at flea markets and antique stores. They provide a great source of ephemera for mixed-media projects.

USING VINTAGE LEDGER BOOKS IN MIXED-MEDIA ART

Vintage ledger books can be used as substrates as well as collage materials. The pages are a exceptional starting point for mixed media. I begin by prepping the pages and determining how many pages or spreads I will need. To eliminate excess pages, glue pages together or cut them out of the book. If cutting pages out, you want the book to be evenly spaced, so start by eliminating every fifth page in the book. This does two things: It reduces the number of pages and it gives you more room between the covers. Prepare the actual ledger pages by applying a coat of gesso to each. Slide sheets of wax paper between the pages while they are drying and lay a heavy object on the book to reduce buckling. Do keep in mind book pages are not accepted substrates; you will likely have some buckling and curling.

COLLAGE RESOURCES

In this book spread, I included a water-color painting (on rice paper), a tag and a Rub-onz transfer.

THERE ARE NO RULES

In this spread, the pages were covered with a speciality paper and inserts and tabs were made with additional embellishments. A library book pocket, vintage brochures and tags were added as well. The key is not to limit your ideas.

12345
15" × 17" (38cm × 43cm)

MATERIALS

Materials used in these pieces include a watercolor drawing scanned and reproduced on vellum paper; postage stamp; pressed fern leaf and flowers; Grafix double-tack self-adhesive film; ebony graphite pencil; Beacon Zip Dry Glue on Thai paper substrate.

The resources for these pieces are endearing to me. Both pieces are composed of the generosity of others. My friend Nikki Cornett (a former student) gave me the handmade paper that I used as the substrate. She and husband traveled to Thailand and she thoughtfully carried rolls of this beautiful paper through her trip, on the bus and plane, etc. Nikki is an extremely talented mixed-media artist who has taken lessons from me over the years. (I must mention, talent was abundantly evident *before* she began taking lessons with me!) The vellum blueprint drawings are part of a commission job from Kristi Davin; these drawings were originally done by her father. The richness and smoothness of the vellum paper is quite delicious and I gravitated to it immediately. While I was working on these pieces I felt they were yearning for something more. As part of my process I often wander around, pondering and looking for a certain special object. I decided I wanted to add a watch or watch parts, but I didn't have the pieces necessary. I am fortunate to have friends that are generous (and collect ephemera). Friends are a fabulous resource.

ARTWORK ON BLUEPRINTS: TECHNIQUES

I scanned watercolor drawings and then printed them out on the vellum paper. The vellum was sewn onto the substrate (sewing machine zig-zag stitch). The postage stamp was adhered using double-tack. The fern leaf and flowers were applied using Beacon's Zip Dry Glue. The ruler was scanned and printed on multi-media paper, cut and adhered using double-tack. I cut two lines into the substrate to slide the ruler through. The watch part was hand sewn using wire thread. I embellished a few lines here and there with a graphite pencil.

2000
15" × 17" (38cm × 43cm)

❦ PAPERS

This section will touch on the papers most commonly used for mixed-media collage. These are some of the same art papers we discussed in chapter one, however the difference is that we will now focus on using these papers as collage resources rather than as the substrate. So if, for example, you have a watercolor painting that you would like to layer on or into your mixed-media artwork, this section will help you troubleshoot that.

ART PAPER

Art papers are defined as any papers used in the making of artwork; including but not limited too, illustration paper, mixed-media paper, charcoal and pastel paper, watercolor paper, drawing paper. The nice thing about layering art paper onto a mixed-media piece is that they usually acid-free and archival.

Consider the weight, the surface and under surface (flat, porous, clean?) and how to adhere the paper. When deciding on your application, remember to use the appropriate adhesive. Usually there a couple of options for adhering, and the choice is broken down to aesthetics. How it is going to look? These choices are strictly personal, so enjoy the process and decide what works best for you.

BOND PAPER

Bond paper is also known as copy paper. Bond paper is available in different weights and composition. They are not made for artwork, however they can be used in your artwork. I have had great success with bond paper. A few recommendations, use a spray or dry adhesive (wet adhesive will break-down the paper). Top-coat the bond paper with a medium or gesso to give it more stainability.

CONSTRUCTION PAPER

Construction paper is an inexpensive paper available in a color range. Construction paper is not fade proof and does not have archival qualities and will breakdown easily. Pacon Creative Products manufactures Fadeless art paper. This is a premier, ultra fade-resistant bulletin board paper. It comes in a variety of colors, prints and specialty finishes and is acid-free.

CRAFT PAPER

Craft paper is a brown postal paper, commonly known as the paper grocery bag. It is designed with high elasticity and high tear resistance for packaging products. Craft pulp is

COLLAGE PAPERS
Art papers, bond paper, construction paper, craft paper, reflective paper, parchment paper and translucent papers are the most commonly used types of paper in mixed-media collage. Resources of more art paper include printmaking paper, origami papers, tissue papers, velour paper, Japanese printed papers, rice papers and bristol paper.

ACETATE IN COLLAGE

An image is transferred onto self adhesive acetate, cut out, backing peeled away and adhered to the surface.

darker than other wood pulps, giving it's brown color. It can be bleached to white pulp. Because of it's durability, craft paper is a perfect candidate to manipulate by wrinkling. Cut a sheet from the roll, ball it up in your hand, place it in lukewarm water for about a minute, remove and smooth out with your hand, place a heavy object on it and allow it dry on a flat surface.

It is easily found in many different types of stores. It is usually found in rolls, to be used for postal packages. It is also available in sheets. There are different weights and thickness. It receives most wet mediums and adheres well, but consider whether or not it is porous, and if you need it be archival.

MARBLE PAPER

Marble paper comes in light pastel color, blue, gray, rose and tan. It is usually about 80-lb. (170gsm), cover stock weight. It is commonly used for calligraphy. Because of its composition (50% reclaimed fiber), it breaks down with the application of a lot of wet medium.

REFLECTIVE PAPER

Reflective paper or metallic paper is found in a 65–80-lb. weight (137–170gsm). Some are available with adhesive on the paper, making it easy to adhere to flat surfaces. You can find it in different finishes, silver, gold, brass, antique, etc. Some manufactures have metallic paper in designs. The smooth surface needs to be sanded lightly before it will accept wet medium. I recommend cutting or trimming it with a craft knife, this will eliminate wrinkles or tears.

Lightweight reflective papers are also available in a roll, commonly used for gift wrap. These are more of film than paper. I have found the best adhesive process is to use two sided adhesive, such as double-tack mounting film from Grafix (see Chapter Two).

PARCHMENT PAPER

Parchment paper is very similar to marble paper in design and color. Parchment paper is available in sheets that are 65–80-lb. weight.

TRANSLUCENT PAPERS AND FILMS

Translucent papers include Dura-Lar, vellum, acetate, Rub-onz transfer film, tracing paper and clear film. These papers are fabulous for layering, allowing a hint of the underneath to show through. Because of their content, it is best to use a dry adhesive. Several of these papers are available in ink-jet or laser packs; which makes easy to scan or copy images directly onto the surface. Grafix's has translucent papers (Dura-Lar and acetate) that you paint or draw directly on the surface. Some are also available in a self adhesive sheet.

RUB-ONZ TRANSFER FILM

This paper has a two-step application. The image is copied onto the matte film of Rub-onz and then an adhesive sheet is applied. At this point you cut out the image shape, then peel away the clear film, adhere it directly to your surface, rub with burnisher and peel away the matte film, leaving a transparent image. Keep in mind this image is reversed. Therefore if orientation is important to you, make an acetate copy of your image first, reverse it on the Rub-onz matte film. This will insure that your copy is oriented in the correct direction. Plan, practice and produce for success.

Shrink Film | *Follow the steps for using shrink film as a collage resource.*

MATERIALS ink-jet printer multi-use glue Grafix ink-jet Printable Shrink Film transfer image
collage resources substrate

1 CHOOSE YOUR IMAGE
Choose the drawing or other type of image you wish to use.

2 TRANSFER THE IMAGE
Transfer the image onto shrink film using a ink-jet printer. Follow the manufacturer's instructions for printing and reducing the image. It is a simple process. After you have made the copy, you will cut out and bake it in an oven to reduce the image to half the original size. Let it cool.

3 ADHERE THE IMAGE
Adhere the image to the collage surface using a multi-use adhesive (refer to Chapter Two if needed).

Multiple Collage Layers

Follow the steps for creating multiple collage layers.

MATERIALS double-tack mounting film matte gel medium mixed-media board vellum
multi-purpose spray adhesive vintage book or ledger cover vintage postcard wrapping paper

1 ADHERE THE WALLPAPER
Adhere wallpaper to mixed-media board with matte gel medium.

2 ADHERE THE VELLUM
Adhere the vellum layer with multi-purpose spray adhesive.

3 ADHERE THE BOOK COVER
Adhere the book cover with double-tack mounting film.

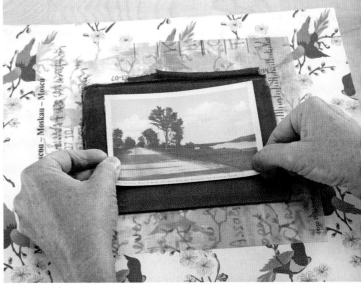

4 ADHERE THE POSTCARD
Adhere the vintage postcard with double-tack mounting film.

PHOTOGRAPHY

Photographic collage resources includes photo prints, slides and film. The digital age has changed the face of photography in many ways, and photos often never become prints, remaining forever floating on the computer.

To preserve the integrity of the original, mixed-media artists using vintage photos choose to make a copy or scan the image onto paper and then adhere to the art. You can also use the copy to try different techniques or media. Perhaps, you have a black-and-white photo that you would like to introduce color. Try printing your photo on a mixed-media paper and then use watercolor or colored pencil to enhance the image.

MAGAZINE PAGES

Magazine pages are one of the most readily available collage resources. Typically magazine pages are slick surfaces, that break down easily. The ink on the magazine page may transfer or smear once wet. You may want to embrace the tears, wrinkles or smearing; if not, consider covering the page with a coat of matte medium. You can also make a copy or scan the magazine image onto a different paper. Choose the adhesive to fit the need of your project.

PHOTO FILM STRIPS

Photo film strips are negatives that have not been cut and popped into a slide mount frame. Because of their size, photo film strips or negatives can add an intimacy to artwork. You can adhere the negative on the art with adhesive or by sewing. Choose the adhesive to fit the need of your project. Film strips are also on reels. There are different size reels and films (depending on the camera and use). Homemade movie reels are usually small reels containing thin strips of film.

For a variety of looks, try adhering tiny gems or jewelry findings to a negative. Loop or weave film strips and then adhere onto the art. The non-porous surface is not conducive to paints or other medium. However, and I love this, there are spray paints that adhere to plastic. Try spraying several strips of film, allow it dry and then apply it to the surface of your art.

Remember to always keep in mind copyright laws and usage. Remember, most anything can be a collage resource. The items listed in this chapter are a resource guide for you to learn what works best for your needs. I encourage to experiment and follow your heart.

SLIDES

Slides are fun elements to introduce to artwork. I like to add slides to my work to engage the viewer to come closer. Often, placing the slide where it may be removed or easily seen. I also, like to use slide frames and pop in my own drawings or images and then adhere them to a layered background. I recommend using dry or wet adhesives to adhere slides.

RESOURCES FOR PHOTOGRAPHIC MATERIALS
Resources for collage photographic materials include magazine illustrations, computer scans, book images, school yearbooks, posters, postcards, photocopies and online resources.

Photographs in Collage | *Follow the steps for adding a photograph in an underpainting.*

MATERIALS collage paper extra heavy matte gel (optional) flat brush gesso ink-jet or laser printer
photograph self-adhesive acetate unprimed canvas acrylic paint scissors flat panel board (optional)

1 PREPARE THE SURFACE

Prepare an unprimed canvas by applying gesso with a flat brush. Once dry, use the brush to paint over the background with acrylic paint (Phthalo Blue was used here.). Set it aside to dry. Once dry, you may select to adhere the canvas onto a hard surface (a panel board). Using a brush to apply an extra heavy gel (matte) on the back of the canvas then adhere it to the board, smoothing down to flatten and eliminate creases.

2 TRANSFER THE PHOTOGRAPH

Copy a photograph onto self-adhesive acetate (available in matte or transparent finish) using an ink-jet or laser printer. In this photo you see the original color photo, a black and white copy on self-adhesive acetate and the image cut out in more detail.

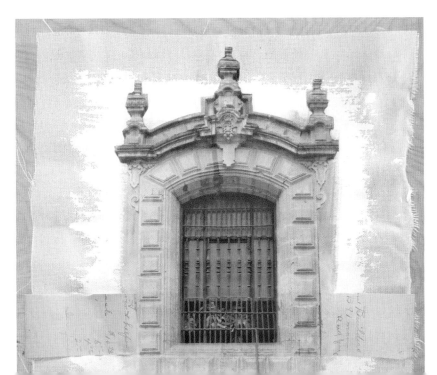

3 ADHERE THE IMAGE

Peel the backing paper from the acetate, hold and position it over the (dry) surface. Smooth out any bubbles or creases with the palm of your hand.

67

Create a Collage Element

Follow the steps to use slide frames and collage resources to create intimate objects of art.

MATERIALS pencil rice paper slide frame small flower or other embellishment craft knife
small flat brush matte medium

1 REMOVE THE FILM FROM THE SLIDE
Use a craft knife to pop open the slide at its side. Slowly peel out the film. It will be sticky.

2 CREATE A TEMPLATE
Trace the film onto rice paper and cut out the template.

3 **APPLY ADHESIVE TO THE EMBELLISHMENT**
Apply matte medium to the back of the embellishment with a small flat brush.

4 **ADHERE THE EMBELLISHMENT**
Lay it onto the rice paper surface and then brush over it with a clean flat brush. This will smooth out any bubbles and get rid of excess medium.

5 **MOUNT BACK ONTO SLIDE**
Once dry, mount the rice paper and embellishment back into the slide. You now have an interesting collage resource for your next project!

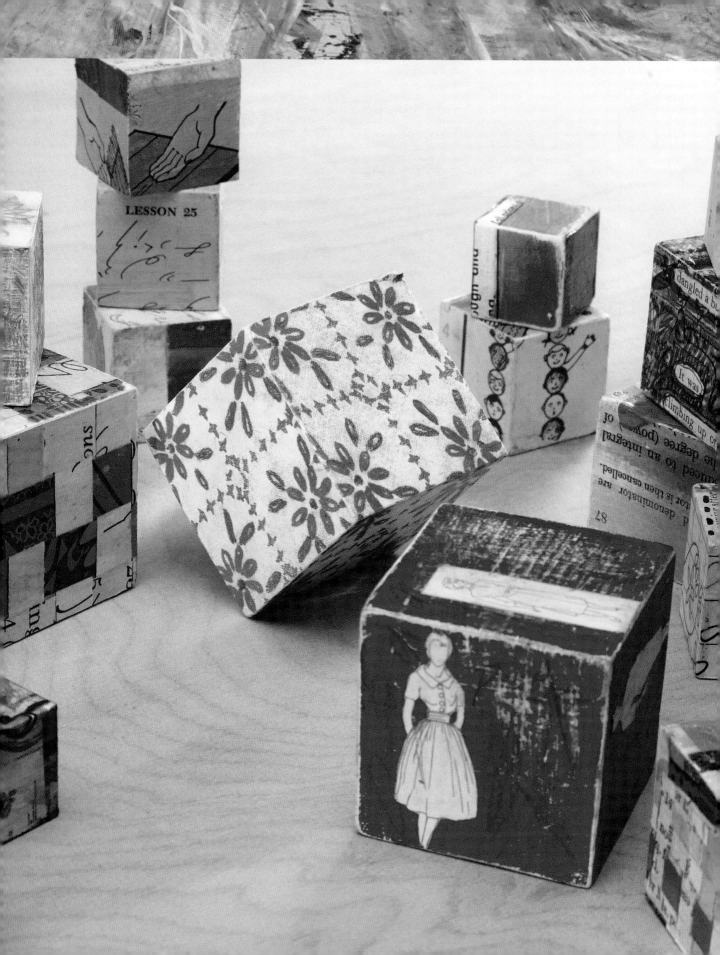

CHAPTER FIVE
OUTSIDE THE BOX

Natural Materials, Building Supplies & Household Items

Mixed-media artists are fortunate to have such a vast array of supplies available to them. Manufacturers have managed to work with artists to mass produce papers, findings, tags, boxes, photographs, stickers, rubber stamps and so on. These products offer mixed-media artists the opportunity to create work without having to hunt down or purchase expense originals. Along with collage resources, mixed-media artists also have a tremendous amount of nontraditional art supplies available to them. However, we all know the thirst for more … the excitement of using unconventional materials in our artwork.

This chapter explores those unconventional materials that have a proven track record as a solid resource for mixed-media projects. Within this chapter you will find suggestions for natural and household materials application and basics regarding safety and archival or product longevity. Offering encouragement and advice, it is my hope that you experiment with some of these materials and perhaps come up with a few different materials on your own.

Remember there are no rules to this genre of art—the sky is the limit. Take a walk and look for pieces from nature. Dig around in your laundry room, clean out the garage or attic. Push yourself to find and discover more ways and materials to enhance your mixed-media artwork.

NATURAL MATERIALS

Nothing conveys beauty more than nature, with its colors and textural qualities. But incorporating actual natural elements in your mixed-media art can be quite challenging. For example, using objects such as leaves or flowers is possible, but there are complicating factors to consider. These objects are organic and will eventually breakdown. One way to help slow down this process is to coat such items with medium or varnish. Another consideration is breakage or deterioration of the object during the application or process of the artwork. Handling natural objects can be a little tricky. Use tweezers for fragile objects like butterflies, flower petals and leaves, and try to minimize the number of times that you pick up or move the object.

Fragility, size, shape and texture are a major consideration for adhering natural objects to a substrate. Fragile objects usually only need a light coat of matte medium to adhere them. The size and shape of the objects has a bearing on type of adhesive as well. For instance, I have had success with using Glue Dots for small branches or twigs. And the texture of the surface accepting the adhesive is also important. A glossy magnolia leaf, for example, will need more attention then a maple leaf.

If necessary, lightly sand the underside of the natural object to help condition it for adhesive. Once the natural object has been attached to the substrate, it can be helpful to cover it with a piece of wax paper and then place a weight (like a heavy book) over the wax paper. This will help to flatten and adhere the natural object to the substrate.

It is possible to paint or embellish directly on a natural object. It is helpful, if you have extra natural objects, to practice first. If this is not an option, then look at the characteristics of your natural object. Is it porous or nonporous? Will embellishing detract from the natural beauty of the object? Will the embellishment have a reaction or deviate from the look you want to express?

FLOWER PRESS

To press flowers or leaves, place them between pieces of wax paper and sandwich them between pages of a book or use a flower press. You may make your own flower press with cardboard and rubber bands. Cut simple squares of cardboard (about the size of a leaf or larger) and sandwich your objects between the squares. Remember to use wax paper on the top and bottom of the object. Wrap the rubber bands around the squares and let sit for seven to ten days in a dry climate-controlled area.

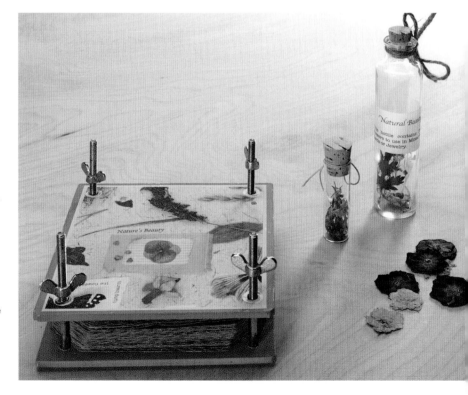

BRANCHES, TWIGS AND TREE STUMPS

Branches and twigs can be adhered with Glue Dots. You can also try other adhesives depending on the weight, size and substrate being considered. I recently embellished a tree stump for a client, painting and adding page cutouts. In the process, I learned a couple of things. Prep the surface by brushing and wiping it down. If possible, begin with a layer of gesso before painting, and allow time to dry between coats. Because the client intended on leaving the tree stump outside, I used a latex exterior house paint.

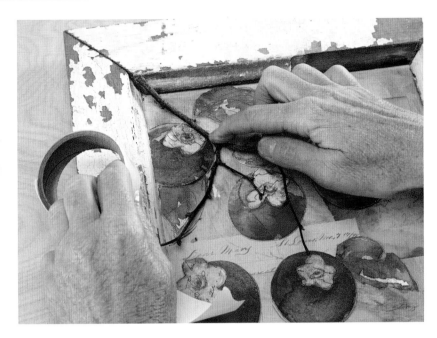

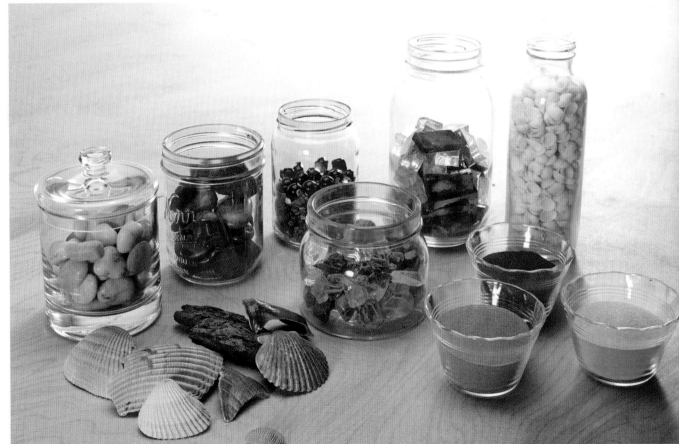

OTHER NATURAL OBJECTS

Natural objects include shells, glass, feathers, fossils, insects and bones.

Pressed Flowers | *Follow the steps for using pressed flowers as collage elements.*

MATERIALS mixed-media board vintage paper and box top pressed flowers
double-tack mounting film small flat brush acrylic panel glazing medium

1 PREPARE THE SURFACE
Cover the mixed-media board with a vintage paper. Add the vintage box top (flattened) for the next layer, followed by the acrylic panel. Adhere all layers together with double-tack mounting film.

2 ADHERE THE FLOWER
Brush matte medium onto the back of a pressed flower with a small flat brush. Lay the flower onto the acrylic panel and gently press it into place.

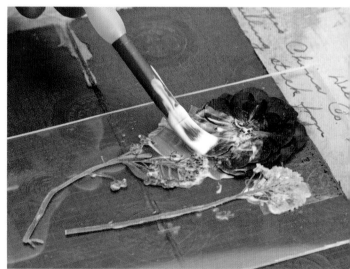

3 GLAZE AND DRY
Glaze with your desired medium and allow it to dry.

BUILDING SUPPLIES

Mixed-media surfaces are often wonderfully tactile and lead you to want to use different materials. The hardware store can be a source for resources such as metal, glass, plastics, tiles and wood. In this section, we will discuss the different uses and application processes recommended for building materials. Whether you are using one of these resources as the substrate or a collage resource, you will learn simple steps to help you along the way.

METAL

Different types of metal are available in a variety of shapes and sizes. You can find flat metal like roof flashing in a roll, and metal pipes may also make for an interesting element. Consider the vision you have in mind for your artwork.

Metal sheets can be cut with speciality tools or heavy scissors. Be extremely careful—metal edges can be very sharp. To reduce the sharpness of the edge, use a fine or medium sandpaper and buff edges. This doesn't necessarily diminish the risk of cutting yourself, but does help to reduce the sharpness. You can also use masking tape and tape the edge for protection while working with the material. I recommend wearing protective gear like gloves and eyewear when working with metal.

There are several paints that adhere well to most metals. The most versatile are spray paints (available in hardware stores). Read all labels and follow the manufacturers' directions.

I have also had success with applying paper collage resources to metal. To do this, lightly sand the surface of the metal with a fine or medium sandpaper and use a dry adhesive, like double-tack mounting film or spray adhesive. Once you have applied the adhesive, lay it on a flat surface and place a heavy weight on top of it to help flatten.

To adhere metal to a substrate, your best bet is a wet adhesive. Once you have applied the adhesive, lay it on a flat surface and place a heavy weight on top of it to help the adhesive and to flatten it.

Try working with the metal in several ways, manipulating it's shape and form. Die-cut or punch holes, hammer or distress the surface, and layer other materials onto the metal.

METAL IN MIXED MEDIA
Metal objects like hinges, handles, pulls, screws, etc., are additional objects that can be used in mixed media. These can be applied in the traditional sense (by nailing or screwing into the substrate) or adhered with an appropriate glue. With the wide variety of different metal surfaces available, experimentation is recommended; explore to discover your personal technique and style.

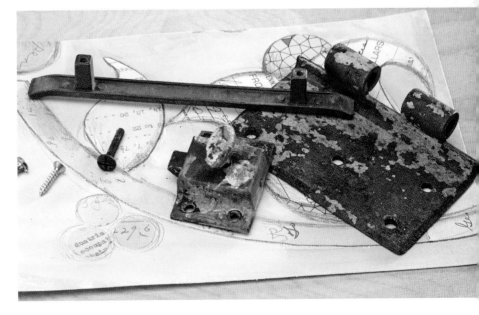

Visit artistsnetwork.com/mixedmediahandbook to access bonus content. **75**

What Is a Patina?

A patina is an organic finish that occurs on the surface of wood or metal while aging. This occurs over time, through oxidation and other naturally occurring chemical reactions. You can, however, create a patina-like look within a shorter period of time. Patina kits are available at most hardware stores. Different metals may require different application methods. Some patinas are better when applied with a spray bottle and others are better when using a brush. Research to determine the best method for the metal you are using. It is important to clean the surface of the metal with rubbing alcohol or recommended cleaner prior to applying patina kits. And wear the appropriate safety gear when working with any chemicals. Once you have completed the patina process, you may want to seal your patina with wax to keep it from changing color.

GLASS

Large sheets of glass can be found in the hardware store. Craft glass or glass for stained-glass projects may be found in art and craft stores. It really depends on what you are looking for. If you desire a large sheet of glass or for a piece of glass to be cut to a specific size, check the hardware store. Most have glass in different sizes and shapes. They also have glass-cutting tools and glass paint.

There are glass tiles, sold in sheets, usually 12" × 12" (30cm × 30cm). These tiles can be cut with glass snips. They are typically used for kitchen and bathroom wet areas. They come in wide range of colors and textures. The best adhesive for glass tiles depends on the surface you are working with. I would recommend looking at a dry adhesive (like double-tack adhesive film) or wet adhesive (like Beacon 527). Definitely experiment and refer to Chapter Two for more information.

With glass, you can place an image on the front or back of the surface, depending on the look you are going for. Layering can be achieved by placing art between two sheets of glass.

To paint or embellish on glass, use glass paints or permanent markers. Remember it you are painting on the underside of the glass, the first layer of paint is the one that will be predominant when viewing from the top or front. This is true for all applications to the underside of the glass (viewing from the top or front). Basically, you are applying the mediums in reverse; foreground and then background.

If you are interested in placing images onto glass, try a self-adhesive acetate, or a Rub-onz transfer. You can copy your image onto one of these papers or films and then apply it to the glass (see Chapter Three). Golden Artist Colors has a crystal texture product that can applied directly to the substrate or mixed with paint. This medium contains tiny crystals of glass that give the surface a reflective look, similar to the reflective look of road signs.

PLASTIC

Plastic can be used as a technique (to achieve a textural surface) or a material (as a collage resource). To use as a technique, embed a sheet of plastic wrap into the wet paint on a substrate and manipulate to desire look. This can be done

with watercolors, acrylics or oils. Any type of plastic sheet will work for this technique, even plastic shopping bags.

Bubble wrap can be laid directly into the wet paint, or paint applied to the bubble wrap itself, and then pressed onto a surface or substrate.

TILE

Tile can be applied to a substrate using an adhesive (see Chapter Two) or compound found in the hardware store. This compound comes in different formulas and sizes. If you are creating a large scale project using tile, I would recommend the compound. It will be more economical. However, for a small application of tile or tile pieces, alternative adhesives will also work.

Painting on tile is quite easy with tile or enamel paints. Tiles may be porous or nonporous, depending on the type. Tiles are available in different sizes and shapes. To cut or trim them, use tile snips or cutters. To break tile, wrap securely in a towel and hit with a hammer. Always take precautions and wear the appropriate safety gear.

The disadvantage of tiles is that it is difficult to achieve an accurate cut without investing in expensive equipment. Also keep in mind the weight of tiles you are applying to the substrate. For good compatibility with tile, I recommend using wood or wood panel as a substrate.

WOOD

Mixed-media artists can incorporate wood sculptures, woodcut prints or wood engravings into their projects. Wood can be cut or trimmed to meet design specifications.

Keep in mind that raw wood will absorb more paint than primed wood, and thin wood may warp. The depth of color depends on the saturation level of the wood and type of paint used. Paints recommended for wood are readily available and easy to find. You may even have some at home. Most art and craft paints work well, but they will be more expensive—especially if you have a large piece to paint. Test and experiment if possible.

Reclaimed or found wood may be a little tricky, mostly because you do not know the history of the material. However, these pieces can be used in mixed media. One of the first things to do is to clean the wood. Use a clean paintbrush or dust broom to sweep away debris, then wipe down with a clean, damp cloth. Allow the wood to dry completely. At this point, you may choose to seal it with a wood sealer or gesso it and paint it. Whatever you ultimately decide to do with the wood, the prep work is very important.

Metal Stencil | *Follow the steps for adhering metal objects in mixed-media artwork.*

MATERIALS hardboard panel collage resources metal stencil Beacon Glass and Metal Adhesive
graphite paper towel

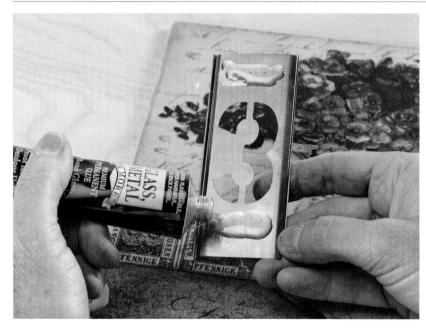

1 PREPARE THE SURFACE
Once you have completed the mixed-media layers desired, apply Beacon Glass and Metal Adhesive to the back of the metal stencil.

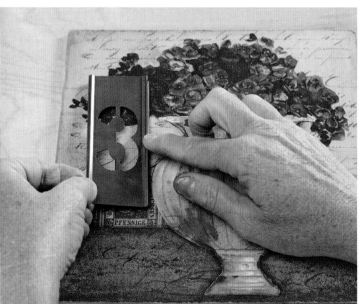

2 ADHERE THE METAL
With the glue face down, hold the metal stencil in place until it is secure.

3 CLEAN IT UP
Wipe away any excess glue with a clean paper towel.

⚜ HOUSEHOLD ITEMS

BLEACH

There are a lot of opportunities for using bleach in mixed-media projects. Bleach can be applied with a paint brush, sprayed from a spray bottle, drawn on with a bleach pen, or applied with rubber stamps or stencils and a stencil brush (not foam brush). The best applications are on colored paper or fabrics. Experiment before you begin on the actual artwork. Create works using one of several bleach techniques and then adhere your creation to your mixed-media project. This will give you a lot of latitude and more room for experimentation.

Bleach pens will give you the control of creating with a marker or pencil. You can achieve more detail and precision. Try applying bleach to your favorite rubber stamp and then stamping it to paper or fabric. Once the paper or fabric has dried, adhere it to your mixed-media project.

Pour bleach into a bleach-safe container and use a paint-brush to apply the bleach directly onto paper or fabric. The bleach can be diluted with water to slow down its effect. Keep in mind that you will not be getting the same textural effects as ordinary painting; rather, the bleach will simply fade out or discharge color from the paper or fabric.

DISH DETERGENT

Liquid dish detergent can used as a catalyst for paint. Mixing one part liquid dish detergent in with two parts water-based paint will extend the paint and area of coverage. Liquid dish detergent can also be used in marbling techniques. Mixing it in with the paint will help to thin the paint and allow it to float on the surface.

FABRIC

When selecting fabric, consider the weight of the fabric, the texture or surface, the type of fabric, the content of the fabric (cotton or synthetic), the adhesive process and durability of the textile.

MORE OUTSIDE-THE-BOX ITEMS

If you're looking for additional household items to experiment with in your mixed-media projects, try a water pistol, drinking straws, a toothbrush, cookie cutters, bamboo sticks, toothpicks, aluminum foil, baby oil or glycerine, cotton balls, cotton swabs, safety pins and cosmetic brushes.

SALT

Table salt or sea salt works well in watercolor painting to pull or tug the watercolor into crystals. Paint the watercolor paint onto a substrate, sprinkle in the salt and watch as it crystallizes, forming tiny starbursts of color.

STARCH

Liquid starch can be used in a variety ways in mixed media. Liquid starch is available in the laundry aisle at grocery stores and (sometimes) at arts and crafts supply stores. Liquid starch is used to harden or stiffen materials such as paper, tissue paper, fabric, string, ribbons and trim. It can be applied with a brush or the material can be dipped directly into the starch. Then you can shape the material or allow it to dry flat.

Place starched materials to dry on wax paper to prevent it from sticking. When applied to tissue paper, the paper becomes glass-like and transparent. Liquid starch mixed with tempera paint (usually powdered) will add a gloss to the paint. It also helps to economize the use of the paint by allowing it to cover more surface area.

WAX OR PARAFFIN

This product normally used in the kitchen for canning is a good material to use as a resist in painting. Melt down the wax and apply it with a natural bristle brush to the surface of the substrate. Then apply paint. Once the paint has dried, remove the wax with a hot iron and layers of newspaper. You can repeat the process to achieve your desired look.

SELECTING FABRIC
Fabric is available in yardage, bolts, rolls, vintage pieces like tablecloths, clothing, quilts and more.

Salt | *Follow the steps for using salt to enhance a mixed-media piece.*

MATERIALS table salt watercolor paints watercolor brush watercolor paper palette water

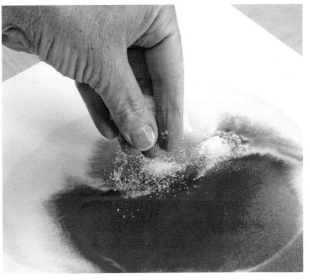

1 PREPARE THE SURFACE
With clean water and a clean brush, saturate the watercolor paper. Add one or more watercolors and continue to paint until the desired look is achieved.

2 ADD SALT
While the paint is still wet, sprinkle table salt into it. Sprinkle as much or little as you like.

3 DRY
Allow the paint to dry.

4 CLEAN IT UP
Notice how the salt pulls and pushes the watercolors around. With a clean dry brush, remove the dried salt from the painting.

Visit artistsnetwork.com/mixedmediahandbook to access bonus content.

Fabric | *Follow the steps to add small or large bits of fabric to your mixed media.*

MATERIALS fabric scraps sewing needle thread collage resources

1 PREPARE THE SURFACE

Cut out a scrap of fabric and position it onto the outer layer of your mixed-media piece. If necessary, secure it with a small piece of painter's tape.

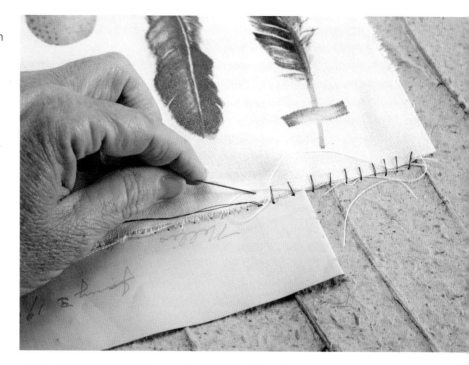

2 EXPERIMENT

When hand-stitching, sometimes it is necessary to create pilot holes by piercing the paper before you hand-stitch the thread through. Explore different types of stitches and looks.

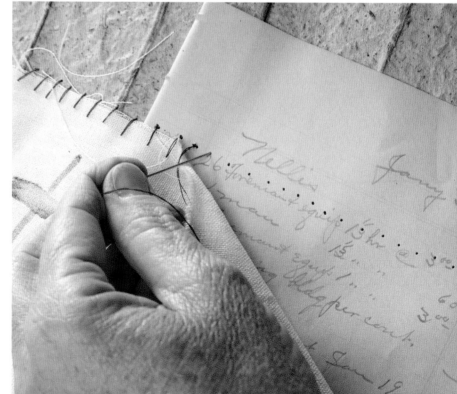

Bleach | *Follow the steps to enhance a mixed-media piece with bleach.*

MATERIALS bleach pen vintage magazine pages steel wool (fine) paper towel

1 PREPARE THE SURFACE
Using a bleach pen, draw or outline directly onto a vintage magazine illustration. Allow this to dry overnight.

2 CLEAN IT UP
Wipe away excess bleach with a damp paper towel or lightly scrub with a piece of steel wool. Continue until you have achieved your desired look.

3 ADD DETAILS AND EMBELLISHMENTS AS DESIRED
The white lines are where the bleach pen was applied. This piece was further embellished with acrylic paint and mediums. Vintage magazine illustrations work well with this media because of the inks used in printing. Try other surfaces, too. Remember to deactivate the bleach with water (on a damp paper towel) or it will continue over time to erode the surface it is on. Use caution when working with bleach.

46

June 22

John Auld — Bliss Job

12", 2

one

2-6"

Loi

+ 2 s

per

John

Apr 4 — Forema

1 ma

1 me

1 ..

John

May 28 Stee

Tax

per cent. — Zeigler Job 19

Buckhart

Duplicate Pads, for use in this Cover, may be
upon application to

MILLS, KNIGHT & CO.

'85

115 CONGRESS STREET, BOSTON.

CHAPTER SIX

MAKING YOUR MARK

Drawing Materials

This chapter will serve as a comprehensive survey of mark-making materials and how to combine them with other mediums. It will list, define and explain different types of pastels, pencils, pens and their companion materials.

When selecting your materials for mark making, apply the following basic questions:

- What type of surface will you be drawing onto?
- Is the surface porous enough to accept the marks? For example, if you want to use a detailed rubber stamps, the surface will need to be flat.
- In what order do embellishments need to be applied?
- How much drying time is needed?

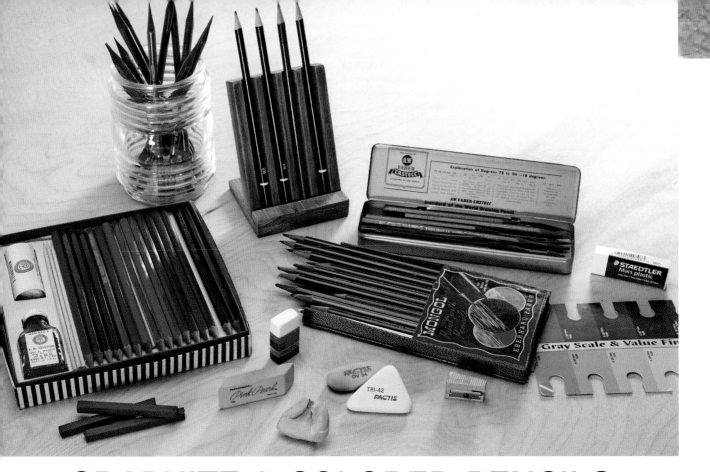

GRAPHITE & COLORED PENCILS

Let's take a look at the characteristics of some of the most commonly used drawing tools in mixed media.

Charcoal comes in the format of sticks, pencils, compressed and pure charcoal. Pure charcoal it is actually a solid chunk of charcoal used for drawing. Willow or vine charcoal sticks are long skinny sticks that come in different degrees of softness. Willow charcoal is produced from willow branches. Compressed charcoal sticks are formed under pressure. These sticks are denser and will not break as easily as vines. Compressed charcoal comes in square and rectangle shapes and in different degrees of softness (2B, 4B, 6B—6B is the softest). Charcoal pencils are found in two types: a self sharping peel-and-sketch form and a regular pencil that must be sharpened with a pencil sharpener.

Colored pencils are unlike graphite and charcoal pencils in that their core is composed of wax with pigments and other additives. The pigments give the pencil color and the propor-

tion of binders, their hardness. These qualities vary among manufacturers and influence things like, lightfastness of the pigments, softness of the lead, range of colors, price, durability and longevity of the colored pencil.

Oil-based and water-soluble colored pencils have been the choice for professional artists because they are considered to be higher of quality than wax-based colored pencils. However, these differences remain a matter of personal preference.

When selecting colored pencils, remember to look for artist grade, lightfastness, break- and water resistance. However, using a student grade colored pencils does have its advantages in mixed media. Student grade colored pencils are usually erasable and easier to blend with a tortillon or blending stump. I also like to use colored pencils as a resist with water-based paints. Try these techniques when using colored pencils with your mixed media:

- Colored pencils can be layered building up several layers of colors, allowing the texture of the substrate to show through. To layer, begin with one color, let's say yellow. Add red on top. Now spin your paper (or other substrate) and add another layer—this time blue. See how the layering changes the depth of the drawing? Experiment with layering, and try adding white to tint the colors.
- Bear down extremely hard with the color pencil to create a waxy surface. This is called burnishing. Brush a light wash of water-based paint over the top of the drawing. Lightly wipe away any excess water and allow the paint to fall into the crevices.
- After you have used the colored pencils, take a small square of fine sandpaper (about 2" × 2" square) and lightly sand the lines of the colored pencil to achieve different shades and tones.
- Create texture by creating a solid waxy surface with the colored pencils and then scratching out hash marks with a bamboo skewer or toothpick.

Graphite pencils are usually made with a small cylinder of graphite and clay surrounded by a wooden casing to grip. They are composed of a compressed mixture of graphite and a clay binder. Graphite pencils are divided into ranges of hardness and softness; the more binder a pencil has the harder the lead is.

Graphite pencils are all marked on a degree scale and are labeled H or B along with a number. The H indicates hard lead, and the B indicates blackness or the softest lead. Pencils can be marked as: 9B, 8B, 7B, 6B, 5B, 4B, 3B, 2B, B, HB, 2H, 3H, 4H, 5H, 6H, 7H, 8H, 9H. The higher the number on the H pencils, the harder it is and the lighter the mark will be. The softest and darkest marks are made by the higher numbers on the B pencils.

The HB pencil is the middle man, not too hard, not too soft it is traditionally known as the number 2 pencil. The mark it makes is dark, but also erasable.

H pencils are the choice pencil for those in detail-oriented jobs, such as engineers, architect and designers. This makes sense because the harder the point the more control you have over the mark. H pencils have a higher concentration of binder or clay than graphite (making them harder) and the B pencils make a softer, darker mark because they have a lower percentage of the binder or clay.

Watercolor pencils are great to use for tight details or drawing. Watercolor pencils, unlike colored pencils (which, again, are primarily wax), are water-soluble. They can be used on a dry surface or wet surface. Experiment with them and get a feel for their range and abilities. I love to sketch in on a mixed media piece with watercolor pencils because they give me the option of keeping them dry (looking like a drawing) or wet (blending in a more painterly fashion) or both! A couple of techniques to try:

- Sketch with both watercolor and colored pencils, then use a brush dipped in clean water and brush over the surface. The watercolor pencil strokes will breakdown, while the wax or colored pencil marks will remain intact.
- Brush the surface of your substrate with clean water, and while wet, draw with watercolor pencils. Let the magic happen.
- Use watercolor pencils on a textile (results will be better if you use 100% cotton pre-washed), brush over the drawing with a mixture of clean water and matte medium. Let dry.

DIFFERENCES BETWEEN PENCIL GRADES

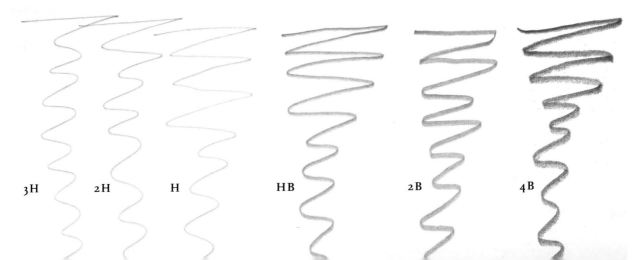

3H 2H H HB 2B 4B

Colored Pencil on Dura-Lar | *Follow the steps for using colored pencil on Dura-Lar.*

MATERIALS Dura-Lar sheet colored pencils graphite pencil scissors multi-purpose spray adhesive

1 SELECT A SURFACE
Begin with a clean Dura-Lar sheet.

2 SKETCH AND COLOR
Draw your design directly onto the Dura-Lar sheet with a pencil. Color it in with colored pencil. (You could also use watercolor pencil for a wet look.)

3 CUT
Cut out the image.

4 ADHERE IT
Adhere it to your chosen surface with multi-purpose spray adhesive.

Blending Colored Pencil | *Follow the steps for blending colored pencil.*

MATERIALS colored pencils cotton swab blender pencil

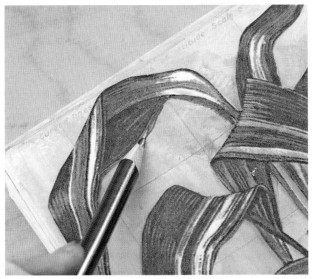

1 LAY IN THE COLORED PENCIL
Lay in your composition with colored pencil as desired.

2 BLEND WITH A COTTON SWAB
Use a cotton swab to blend areas of colored pencil with broad strokes.

3 REFINE WITH A BLENDER PENCIL
Go in with a blender pencil to further blend and refine smaller areas.

✿ PENS & MARKERS

Pens come in a variety of types and can offer different results. Even writing pens have a range of tips: extra fine, fine, medium and so on. When you're working with pens in mixed media, they should usually comprise one of the final layers. This is because inks can be volatile to other liquids and may smear. Also, the line from a pen is a nice final touch.

Pen types include quill, dip, ball-point, gel, roller and technical. Dip and quill pens are similar to calligraphy pens and have nibs or tips. Dip pens are a little more restrictive, allowing you to make a stroke in only one direction—the pen must be pulled toward you, but not pushed away from you. Technical pens allow you to stroke in any direction. A technical pen is reliable in the sense that it will lay down a uniform mark (uniform line).

Markers are available with a wide range of features. Art stores sell them individually and in sets. It may be best to buy a few different types before investing in a set. Some designer markers are refillable, which helps keep costs down. Markers come in solid tips and different sizes and produce different width lines. Some also come with brush tips. Similar to a paintbrush, the brush tip handles easily and it is good for large areas or for producing painting-like strokes. To create a wash or color gradations, use a colorless blender marker along with the color markers.

Bamboo pens are made from a stick of bamboo and sharpened at one end. This type of pen must be dipped into ink to load. The ink will cling to the underside of the point and make a mark when applied to a surface. Bamboo pens are inexpensive and a simple way to apply ink to mixed media.

Calligraphy inks come in black and white and a range of colors. The ink is available in different container shapes and sizes, waterproof, nonwaterproof, lightfast and free flowing.

Calligraphy markers come in a range of colors. These markers have a chisel point. Some are available with a double head and have both a wide point and a narrow point.

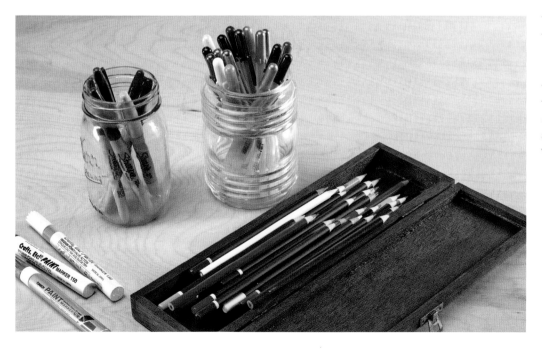

WATER AND WATERCOLOR PENCILS
Brush water over watercolor pencil to allow the pencil marks to bleed and blend like watercolor paints.

Calligraphy pens come either self-loading (cartridge refills), as a holder with loading nib (you must dip it in ink) or as self-loading no-refills (like a marker, when it is out of ink, it is discarded). Nib or tips come in different sizes, which in turn, makes different strokes and lines. Calligraphy is a lettering art form and is popular with mixed-media artists, especially in journaling.

Chalk markers are basically dry-erase markers, designed to be used on white boards, blackboards, glass and paper. They come in a range of colors but not tip sizes.

Fabric markers are designed to be used on textiles. They are permanent and work great on canvas.

Gel pens are pens with liquid and gel ink that produce raised lines and glossy effects. They come in a wide variety of colors, fluorescents and metallics. Gel pens are an easy way to add an embossed look on the paper.

Glass paint markers are paint markers designed to be applied to smooth surfaces like glass. There are a couple of types: one that is permanent (baked on) and one that can be removed with a wet cloth.

Graphic pens are generally used for lettering and drawing and come in a variety of sizes, styles and colors. They are available in both refillable pens and non-refillable versions and are permanent and non-smearing. These pens are great for the Zentangle method of drawing.

Ink markers contain dye-based, permanent translucent ink. They offer deep saturation and produce rich colors.

Lumocolor Markers will write or draw on smooth surfaces such as paper, glass, plastic, ceramic and metal. Like Vis-à-Vis markers, they work great on acetates.

Mean Streak makes a white marker to be used on dark surfaces. It is permanent and waterproof.

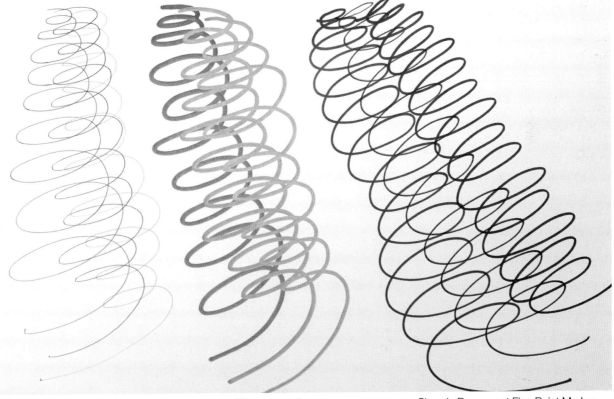

PEN AND MARKER LINES

Gel Tip Pen

Water-based Pigmented Marker

Sharpie Permanent Fine Point Marker

Memory Pens are archival, acid free, non-toxic pens. They are perfect for using with photos and mixed media.

Oil-based paint markers are like painters markers except they are filled with oil-based paint. They are good for adding detail and are water- and fade resistant.

Painter's markers are markers filled with acrylic paint. These markers are perfect to use with acrylic paint. They blend well and look just like acrylic paint.

Poster paint markers are permanent, water-based, opaque paint markers. They will not bleed through paper or textile.

Rapidograph pens are technical pens used for lettering and drawing. They have hard-chrome stainless steel tips that are replaceable. Technical pens are great for details, and tips come in a variety of sizes.

Technical pens are refillable, disposable pens with disposable cartridges. Technical pens require a bit of care and attention. When they are not in use it is important to keep the cap on; this will help prolong the life of the tip and keep the ink from drying out. They need to be clean to prevent clogging. If a pen sits unused, it is best to clean it first. The more technical pen is used, the better; frequent use helps maintain the steady flow of ink. What does the point size mean on a technical pen? The point size refers to the width of the line drawn. Point size .005, for example, is a hairline, while point size 2.0 equals 2mm (or .079") in width.

"Fixing" a Drawing

When you are using soft graphite, charcoals and pastels, granules, dust and bits of pigment will likely fall from the surface of the art. You have the option of spraying a fixative on the finished work to secure the layers permanently to your substrate. You may also use fixative spray between layers to allow additional layers to be added without affecting what has come before.

Spraying a fixative usually will darken the overall color of the piece. Make a sample and test before using your chosen fixative on any project.

A frequent question is whether hair spray will work as a fixative. The answer is yes—and no. It does work in that it will hold the granules to the surface of the art, but it was not developed as an art supply. So we don't yet know the long-term consequences of using hair spray on artwork as a fixative.

ᘓ STAMPS & INK

Stamping is an efficient way of embellishing mixed-media art. Stamps are commercially available in craft and office stores.

The designs or images on stamps have been laser engraved or carved onto a sheet of rubber. The sheet of rubber is then usually mounted on a wood or acrylic block, making it easier to handle. Stamp designs can also be individually hand carved into pliable materials like erasers or marketed products. A popular children's craft is to carve a design in a potato. Stamp-block supplies come in foam and rubber sheets. The foam sheets are typically thin sheets with an adhesive backing that makes it easy to mount the stamp on a block of wood or acrylic. Because these sheets are thin, most designs can be can be cut with scissors rather than a craft knife. More advanced designs or images can be carved into linoleum blocks using linocut tools. Art companies like Speedball and Elmers X-acto have a range of woodcarving sets, basic carving sets and stamp blocks. An important thing to remember is that the designs will stamp in mirror image, therefore text must be carved accordingly.

Paints, pigments and inks may vary the look of stamps and extend the use of the stamp to different surfaces such as fabric, wood, glass, metal and more. Special types of inks for stamping include metallic and embossing inks.

Stamped images may be embellished with additional mediums, collage, and ephemera. Stamps are handy for repetitive images and patterns.

Stamping cards and papers are created specifically for the use of stamping. They are archival and designed to hold stamped images. They may also be suitable for pen, pencil, light washes, silk screening, crayon and wood block printing.

Stamping medium can be added to water-based paints such as acrylics and used for stamping. It is a great way to save money and utilize paints.

Stamp pads are felt pads saturated with ink (or another medium) and are manufactured in a variety of shapes and sizes. Pads hold the ink or medium that is transferred onto the stamp and onto the finished surface. It is helpful to match the size of the pad to the stamp. (It is better to use a pad larger than stamp rather than smaller than the stamp).

Stamp pad re-inkers are refills for stamp pads available in a range of colors.

INKS AND
SCRATCH
BOARD
SUPPLIES

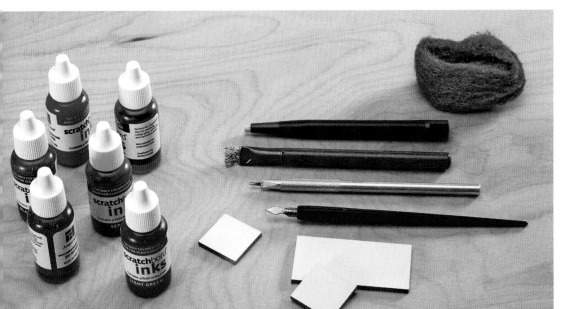

PASTELS

Pastels come in different forms and formulas: soft, chalk, oil, fabric and wax. They may be in stick, block or pencil shape. Typically, when people use the word pastel, they are referring to dry—or chalk—pastels. Pastels are fragile and have low resistance to wear and tear They are more affected by everyday conditions like sunlight. They also have a low adhesive quality, which means they can easily flake off your art. There are ways to help remedy these characteristics. One is to use the proper fixative or topcoat sealer.

Chalk pastels are normally referred to as soft pastels. Soft pastels are a combination of chalk (a soft limestone), pigment and a binder. The binder is not to bind the pigment to the surface of the substrate but to hold the pigments together in the pastel. The higher the proportion of a binder, the harder and more brittle the pastel. Chalk pastels come in three different forms: soft pastels (less binder), hard pastels (more binder) and pastel pencils.

Pastel pencils do not go as far as sticks, but they handle nicely (no dusty hands) and can be sharpened for tight details. Pastel pencils offer the same blendable beauty as other pastels but with less mess and more control.

Mixing color in pastels is not like mixing paint. This is especially apparent when shading or tinting with black and white. Premixed pastels are available in a wide range of colors, shades and tints. Adding wet mediums to pastels is a great way to build up layers, set up a ground coat and help blend pastels. The rougher or more textured the work surface, the more layers of pastels can be applied. More layers can be built up by adding a spray fixative between layers.

Keep in mind that pastels are dusty and can raise a reasonable concern for health risks. Never blow the loose dust; rather, tap the surface lightly outside to dislodge and eliminate dust. When working indoors, keep a small dust buster handy to vacuum up the dust and wear a protective mask and clothing.

China markers—or grease pencils—are wax pencils usually used on nonporous surfaces such as glossy papers, glass and

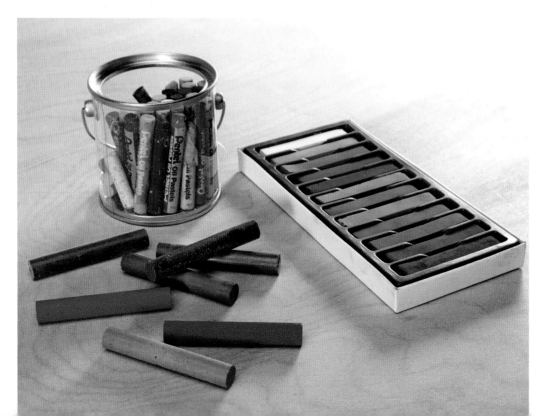

PASTELS
Pastels come in soft, chalk, oil, fabric and wax varieties.

ceramics. They are similar to crayons in content and are non-toxic. China markers are great to use in mix media and are resistant to moisture.

Conté crayons are drawing pastels that are a hybrid between a dry (or chalk) pastel and a crayon (wax). Conté crayons are available in variety of hues. Conté crayons are usually square shaped, which makes it easy to use the flat side for broader coverage. I like to use Conté crayons in the final step of my mixed media as a highlighter and/or for placing shadows. You can also achieve a nice crisp line by using the corner edge, or blend with a cotton swab or tortillon for a softer line.

Crayons are a inexpensive way to add a layer to your mixed-media project. Crayons are not as soft and buttery as oil pastels or Cray-Pas. They are normally non toxic and available in a wide range of colors. Crayons are composed of wax and can be used as a resist to water-based paints or a layer that you can scratch into to reveal an underlayer. To try one of these techniques, simply begin with a layer of paint, let it dry and then cover it with a solid layer of crayons. Use a sharp object, like a bamboo skewer or toothpick and scratch lines into the crayon. For the resist technique, begin with the crayon, making marks on the substrate, then paint a layer of water-based paint over the entire surface. The area that is not covered with crayon should absorb the paint, the crayon will resist the paint. Scratch through the paint to expose the crayon underlayer. Experiment and have fun using crayons.

OIL AND SOFT PASTEL DIFFERENCES

Oils Soft Pastels

Fabric pastel dye sticks are great for drawing designs on clothing and textiles. The colors are soft and blendable and can be heat-set for permanent results.

Oil pastels come in sticks, handle evenly and without stickiness. On the surface they provide excellent stability. They are available in a wide variety of colors and offer creamy texture and even pigmentation. Oil pastels are affordable and work well with mixed-media techniques. They are comprised of oil and wax ingredients. The bad news is that they also smear easily. Therefore, it is imperative that you protect the art as you are working on it. The good news is that there is no dry time. Oil pastels may be moistened and brushed with turpentine or mineral spirits to make a wash. They may be applied over other mediums and collage layers. Some oil pastels are water-soluble and can be used wet or dry.

Oil sticks are comprised of pigment, oil and a wax. Oil sticks work very much like oil paint. They may be thinned with any oil solvent to a wash or brush consistency. They are easy to control and dry more quickly than oil paint. Oil sticks are fun to use and add a richness to your mixed-media techniques. Oil sticks have a slower drying time and need solvents to help blend and clean up. This can pose some health risk; be diligent about following all manufacturer's instructions. Oil sticks have a high resistance to their physical environment and adhere well to most substrates. Keep in mind that they are composed of oil and can have adverse effect on substrates like paper and fabric. Test and experiment before adding to your art.

Pastel brushes are used for blending and cleansing soft pastels. They include a fan brush, angular brush, oval blending brush, flat brush and sponge brush.

Pastel holders are a handy tool for holding pastels and keeping your hands and substrate clean. You only need one because they are hollow metal or plastic holders that fit over your pastel, allowing you to change pastels as needed.

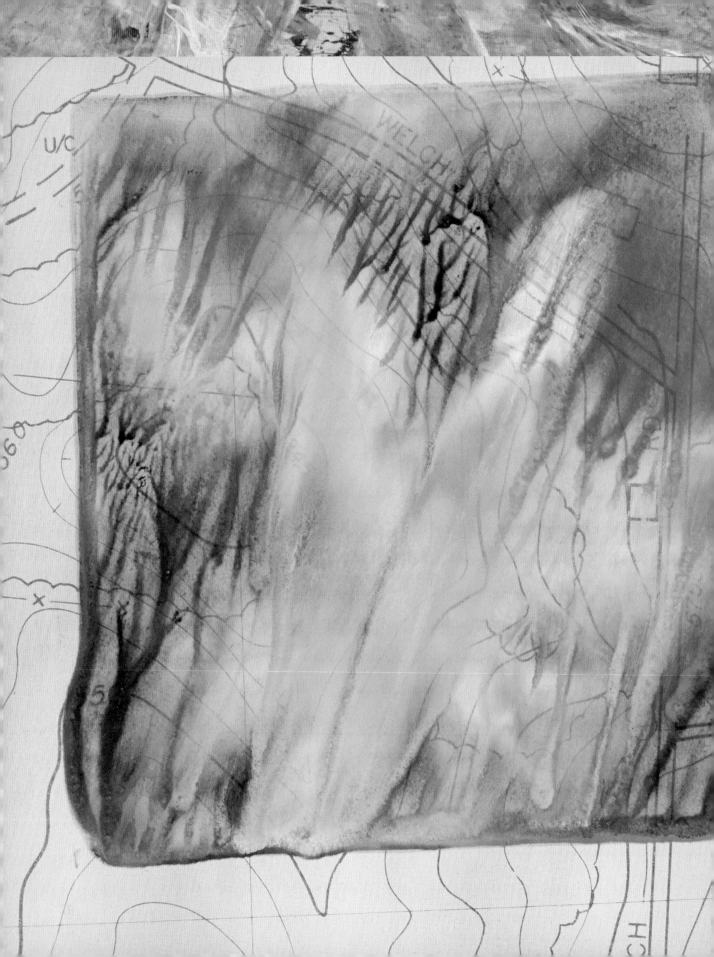

A STROKE OF GENIUS

Painting Materials

This chapter includes an easy to follow guide for how to use acrylic paints, inks, encaustics, gouache, oils, tempera, watercolor paints and brushes. The labels on your paints can provide some of most valuable information you need as a mixed-media artist. In the following pages, you will find descriptions of the different paints and their various qualities, as well as many other helpful tips for painting. Consider the following when choosing which paints or other wet mediums to use in your projects:

- What type of substrate are you working on?
- What kind of collage resources have you selected?
- Do you want to use more than one medium? If so, consider the sequence to which they need to be applied. For example, if you are working with acrylic paint and oil sticks, it important to understand that the oil sticks will resist the acrylic paint.
- How much drying time is needed?

Once all this has been determined, you need to gather your tools and brushes. Before you get started, read through this chapter and it will guide you along with tips and hints on preparation to help make your mixed-media project successful.

BRUSHES & CLEANERS

BRUSHES

Artist brushes are available in a variety of shapes and sizes. They are addressed by names that refer to the type of material used to make the brush head, the shape of the brush head and the size of the brush head. Generally, the same brush from different manufacturers is named the same. But beware that some manufacturers may have different names for the same type of brush.

A paintbrush is constructed in three parts: the head, the handle and the ferrule. The brush head is the functioning part of the brush and consists of a bundle of filaments in a shape such as flat, round or curved (usually referred to as filbert).

The ferrule is the metal clasp or sleeve that grips the brush head and attaches it to the handle of the brush. Ferrules are usually constructed of nonrusting metals and have no seams (which prevents liquid from slipping inside and loosening the adhesive that holds the filaments in place).

Brush handles are traditionally made of wood and stained, painted or glossed for longevity and grip. However, handles do come in other materials as well, such as plastic (some with foam grips) metal and hard acrylic. Brush handles are either short or long based on intended use. Long handle brushes are designed for painting at a distance from the painting surface—such as on an easel. Watercolorists traditionally work on a horizontal surface and hold their brushes like a writing utensil, so their brushes are designed with shorter handles.

The filaments of a brush are either synthetic, soft animal hair (like camel) or stiff bristles (such as horse hair). Better quality filaments have greater "spring" or ability to snap back to their original shape after each stroke.

As a general rule, any type of brush may be used with any medium. However, manufacturers now package and make recommendations for the use of the brush. Synthetic brushes are recommended for acrylics, tempera and gouache. Bristle brushes are recommended for oils and thicker paints. And soft brushes are best used for watercolors, acrylics, tempera and gouache.

The cost of brushes varies and is based on the expense of the filament. The higher cost brushes are usually soft animal hair brushes made from sable.

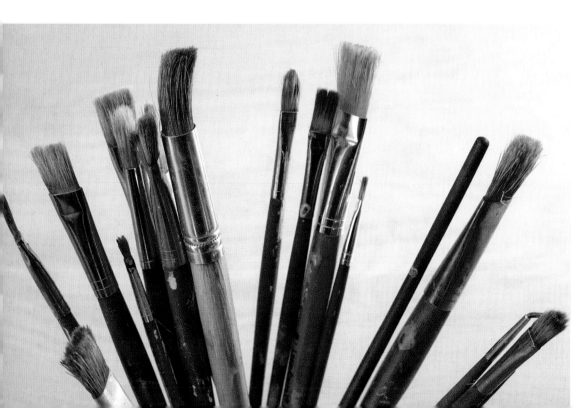

BRUSH VARIETIES
Brushes are available in a variety of sizes and shapes, including flats, rounds, brights and filberts.

- **Ox hair brushes** have good spring and come from cattle.
- **Bristle brushes** are course and strong and come from hogs.
- **Camel hair brushes**, believe it or not, come from a range of animals, such as squirrel, goat and horse, but not camels. These brushes vary in composition and price.
- **Squirrel brushes** are actually made of squirrel hair and are usually inexpensive. They hold a lot of liquid and are great for wet-on-wet watercolor techniques.
- **Synthetic brushes** use man-made materials like polyester and nylon. These brushes are universally available and can be used with all mediums with good results but are typically used in acrylic painting.

The key to success with any tool is maintenance. Clean your brushes properly and regularly. Use a brush cleaner for acrylics. For oil paints, use turpentine (or a brush cleaner, and use mineral spirits in place of water). Store your brushes by keeping them upright (brush head up) or by laying them flat to maintain their shape.

BRUSHSTROKES

Brushstrokes are determined by a few things: the type of paint and medium used, the filament material, shape and size, and the technique or style in which you lay down the paint. Let's review at the different brush shapes to help direct you with your selection:

- **Flat.** This brush tip is usually long and flat. It's used for filling in and linear strokes. You can use the flat side of the brush for broad strokes, or rotate the brush in your hand and use the narrow side for more precision.
- **Bright.** Brights are also referred to as short flats. They resemble flat brushes but the head is not as long. Brights are used for the same techniques as flats or long flats, they hold less paint and offer more control.
- **Filbert.** This brush is similar to a flat but with a contour or round edge. Filbert tips work like flats and give you a curved line. This brush is nice to use when painting flowers and cylinder shapes.
- **Round.** It's round, pointed brush tip is used for making lines. The more you apply pressure, the broader the line will be.

- **Spotter.** This tiny pointed brush tip is used for fine details. It resembles the type of brushes that are used in model making.
- **Rigger.** Also called a script or liner brush, it has a long brush head relative to the diameter and is used for detailing, lettering and scripts. The brush head may be pointed or blunt tipped.
- **Wash.** A wash brush is a large, wide and flat brush used to coverage larger areas.

OTHER SUPPLIES

Mineral spirits act the same as turpentine but with less odor. Use mineral spirits to clean and thin oil-based paints. Mineral spirits store well and are inexpensive. Caution is advised when using any thinners or other chemicals.

Paint thinner is the same as turpentine and is used for all types of oil paint, varnishes and enamels. It thins paints and cleans brushes and other tools. Look for a mild, colorless and odorless formula. Organic solvents and thinners are also available.

Turpentine is a solvent for oil paints. It is made from pine sap. Turpentine is flammable and needs to used and stored properly. Please read all manufacturers' guidelines regarding usage and safety.

Safety First!

Requirements regarding labeling safety information on products vary from country to country. Paints made in the USA are labeled according to ASTM (American Society for Testing and Materials) standards. ASTM standards for labeling art materials include information pertaining to chronic health hazards, standard specifications for artist's oil, resin-oil, and alkyd paints, standards specifications for artist's acrylic dispersion paints as well as other required health warnings. Check for the ACMI (The Art & Creative Materials Institute) approval seal on a product label to verify that it is non-toxic.

PAINTS & OTHER WET MEDIUMS

ACRYLICS

Acrylic paint is a fast drying, water-based paint containing pigments suspended in acrylic polymer emulsion. It can be thinned with water and is water resistant when dry. This paint can be used on any paper surface or primed board or canvas and can be used indoors or outdoors. The biggest advantage to acrylic paint is that it can hold other mediums on its dry surface, and you can mix other materials like sand, grass, flowers, paper, etc., into it.

Keywords to look for when selecting an acrylic paints are: brilliant, good pigment strength, flows easily (viscosity) and contains no solvents. If you are painting on something that will be washed or exposed to a lot of light, look for medium viscosity, excellent coverage, high pigment, lightfast, permanent acrylics.

Higher quality (or professional grade) acrylic paints contain no fillers, extenders, opacifiers, toners or dye additives. They will mix well with acrylic additives and gels. Single pigment colors have the cleanest mixing results. Student grade acrylics are similar to professional grade but with lower pigment concentrations and a lesser range of colors. Colors can be mixed but with lower color strength. The least expensive option is scholastic grade acrylics, which have the least expensive pigments or dyes. These paints are perfect for students and economical for large groups. The color range is limited, however, and lightfastness may be poor.

Acrylic retarder will slow down the drying time of acrylic paint without impairing consistency or texture. Acrylic retarder can be thinned with water.

Craft acrylics are a convenient and economical choice, available for a range of surfaces. Colors can be premixed or mixed, however, pigments are not often specified.

Exterior acrylics are paints that can withstand outdoor conditions and adhere to many surfaces. They have all the same great qualities of interior acrylics with one major difference: exterior acrylics are more resistant to both water and ultraviolet light. Therefore, if your mixed-media project will be outside, this is a perfect choice.

Fluid or soft body acrylics are available in artist quality or craft quality. These paints are good for watercolor and airbrush techniques. Fluid acrylics can be mixed with mediums to thicken them or thin them for glazing applications.

ACRYLIC PAINTS
Acrylic paint is flexible and has an elastic quality once dry.

ENCAUSTICS

Encaustic paints from Enkaustikos are available in round cakes, hot cakes (refillable flat bottom metal tins, and hot sticks that are easy to hold for printmaking and instant melting, They also come in wax snaps that look similar to candy bars—they snap off to give you just the size you need to refill a Hot Cakes tin.

Heavy body acrylics are thicker and are known for exceptionally smooth consistency. The heavier the paint, the thicker, which allows you to achieve peaks and sculptural effects. Heavy body acrylics will hold a brush or palette knife stroke nicely. Interactive acrylics are acrylic paints formulated to allow artists more open or working time.

Metallic, iridescent and pearl acrylics have colors comprised of pigments combined with powdered mica or powdered bronze to add a shimmering or metallic characteristic.

Open acrylics were created by Golden Artist Colors to address the major difference between acrylic and oil paints' drying time. This paint contains a hydrophilic acrylic resin, which lengthens the amount time the paint stays wet. Keep in mind that many characteristics play into open time, including substrate, paint thickness, layering, climate and so on.

ENCAUSTICS

Encaustic paints are also known as (hot) wax paints. The process involves painting with heated beeswax combined with colored pigments and damar resin. There are several different application processes and techniques.

Damar resin crystals are mixed into beeswax to harden it and raise its melting temperature. It is easier (and safer)to by manufactured encaustic paints that already have the resin (and pigments) mixed in.

Encaustic medium is a blend of white filtered beeswax and damar resin. This product can be used mixed with any encaustic paints or pigments. It also can be used alone for collage techniques of layering. (Unfiltered medium is also available and has a yellowish cast to it.)

Enkaustikos offers a fine line of encaustic products. There are no oils or solvents in these paints. They are made from a blend of USP Beeswax (mechanically filtered beeswax not purified with harsh chemicals or bleach), high grade damar resin, and artist grade pigments. Their wax paint is available in round cakes (the most economical choice), hot cakes (refillable flat bottom metal tins), and hot sticks that are easy to hold for printmaking and instant melting, They also come

in wax snaps that look similar to candy bars—they snap off to give you just the size you need to refill a Hot Cakes tin.

Filtered white beeswax is similar to white beeswax pellets. It is a filtered granular white beeswax that has not been bleached. It can be mixed with encaustic paints and other painting mediums.

Slick Wax eliminates the need for any type of solvent in your studio. Simply have a pan of melted Slick Wax available during the entire painting process and just "rinse" your brush or tool in the Slick Wax between color changes.

Wax Pastilles are small beads of naturally white unbleached beeswax manufactured by Gamblin Artist's Oil Colors.

White Beeswax Pellets are pure refined natural beeswax pellets for use in encaustic and other painting mediums. They are manufactured by Eco-House, Inc.

INKS

Alcohol inks have an odor, so make sure you are in a well ventilated room when using them. These inks have brilliant saturation and mix well with one another. Alcohol inks can be used on a variety of surfaces including paper, plastic, metal, glass and vellum.

Clayboard ink is an ink set specially designed and formulated for use on clayboard. This ink is versatile and can be used for painting, calligraphy, airbrush or in precision and detail. It is water resistant and lightfast.

Colored acrylic artists inks are acrylic-based pigmented water-resistant inks with a high degree of lightfastness. Daler Rowney has a line of these inks that are fully intermixable with other Daler Rowney inks.

India ink or drawing ink is usually used with calligraphy or in pen and ink drawing techniques. It is a permanent waterproof ink that is free-flowing and fast drying. It will erase from vellum film or drafting film. Liquitex, Higgins, Holbein, Windsor & Newton, Speedball, Koh-i-noor and Dr. Ph. Martin all have lines of drawing inks. They vary in their characteristics, but all offer a good medium for drawing, air-brush and calligraphy.

OILS

The color in oil paints comes from small particles of color pigments mixed with a carrier such as linseed oil. Pigments may be derived from the earth, (like sienna or umber), living organism (such as roots and berries) or metals (like iron oxides). This is pretty amazing stuff and is reflected in availability and price. Rest assured, synthetic pigments are also available, adding an increased availability of colors and excellent lightfastness.

Historically, pigments were dangerous and highly toxic. Fortunately, many of those pigments are no longer manufactured and have been replaced by safer synthetic versions. However, there are still some made that are toxic to some degree. Vermillion red uses natural or synthetic mercuric sulfide or cinnabar (mercury), cobalt violet is made with cobalt arsenate. Be conscious of your decisions and you will safely enjoy the beauty of oil paint and mixed media.

INK ON SCRATCH BOARD
Ink is brushed onto a scratch board with a flat brush. Once dry, a design can be scratched out with a craft knife.

Artist oil paint is a slow-drying paint with pigment suspended in linseed oil. Look for consistency and mono-pigment for color brilliance on the label. The viscosity (remember that word?) of the paint may be changed by adding a solvent such as mineral spirits or turpentine. The slow dry time of the oil paint allows more time for manipulation of the paint, blending, mixing and adding texture. Keep in mind that the oil paint may damage or stain papers, photos or other ephemera.

Oil sticks are often a preferred type of oil paint because of the easy control they afford. Oil sticks are easily blended with a brush or fingers. Try dipping your brush into turpentine and brushing over a line created using an oil stick. If you have never painted with oil paints, oil sticks are a safe and simple material to use that will build your confidence and experience.

Sketching oil colors act and feel just like oil paints, but they have fillers added that reduce the cost of the product and earn their reputation as a great sketching paint.

Water-soluble oil colors are oil colors with the same look and feel as conventional oil colors. The difference is that these can be thinned and cleaned up with water.

OTHER PAINTS

Enamel paint air dries to a hard finish. Typically, "enamel paint" describes oil-based products with a significant amount of gloss in them. However, there are latex and water-based paints that are branded enamel paint. You can find enamel paint in different forms, such as spray paint and brushable. Different categories of enamel paint include model paint, engine paint (which can withstand high-temperatures), appliance enamel paint (usually a fast dry enamel that is commercially sprayed on), and floor enamel (which can be used for concrete, stairs, porches, etc.). Enamel paint is also used in professional sign painting.

Gouache is a paint that is similar to watercolor but is opaque. Its quick coverage and opaqueness make it more like acrylic in look than watercolor. Gouache generally dries to a different value than it appears when wet (lighter tones generally dry darker, while darker tones tend to dry lighter), which can make it difficult to color match over multiple painting sessions.

Latex paint is non-toxic, low in odor (compared with oil-based), non-flammable, with a water-soluble base that's easy to clean up.

Tempera, also known as poster paint, is a permanent, fast-drying painting medium. It is available as a concentrated powder or pre-mixed liquid. It can be used with many surfaces including wood, plaster, fabric, board and paper. It is non-toxic, water-soluble and dries to a brilliant finish, with a pastel-like look. Because it is very affordable it is commonly used in school art programs and is suitable for a wide range of projects.

Tempera is normally applied in thin, semi-opaque or transparent layers. Tempera painting allows for great precision when used with small brush strokes. Because it cannot be applied in thick layers as oil paints can, tempera paintings rarely have the deep color saturation that oil paintings can achieve.

The classical form of tempera paint is egg tempera. In this form, egg yolk is used as binder. Egg tempera is water resistant, but not waterproof. Other preparations use the egg white or the whole egg for different effects. Other additives, such as oil and wax emulsions, can modify the medium. Egg tempera is not a flexible paint and requires stiff substrates. Painting on canvas will cause crackling and pieces of paint to fall off.

Watercolor paints are available in tubes, liquids, cakes and pencils. Liquid watercolors are highly concentrated and have brilliant color. The traditional watercolor cakes are an excellent value and perfect for practice painting. Watercolor can be reactivated once dried; just re-wet the palette and apply. Because it is opaque, using white watercolor paint will muddy up the transparency of other pigments.

Watercolor pencils can also be considered a painting medium. Unlike colored pencils, watercolor pencils can be used on a dry or wet surface. Brushing water over watercolor pencil will cause the color to bloom and bleed, creating a watercolor paint effect. Experiment with watercolor pencils to get a feel for their range and abilities.

Helpful Painting Guide

If you're painting on …

BRICK

Prep Prep with a wire brush and muriatic acid, white vinegar, baking soda.

Paint Masonry sealer, latex paint

Tools Long nap roller and brush

Tips Apply masonry sealer let dry and then paint.

CERAMIC

Prep Sand with 150 grit sandpaper and wipe of with damp cloth.

Paint Ceramic paint, gloss or semigloss latex or plastic paint

Tools Short nap roller and brush

CONCRETE

Prep Prep with a scrub brush and degreasing solution.

Paint Masonry paint, enamel paint or epoxy paint.

Tools Roller

FOUND WOOD

Prep Prep with a paint scraper or rotary sander - wear a protective mask.

Paint Acrylic paint, latex paint, oil-based paint, primer if desired

Tools Roller and brush

Tips Be aware of the possibility of lead paint - please take precautions.

FABRIC

Prep Wash and dry fabric before painting.

Paint Water-based paint and textile medium or textile paint.

Tools Paint brush or foam brush, sponge or stamp

Tips Do not use fabric softener when washing the fabric.

GLASS

Prep Wash in soapy water.

Paint Ceramic paint, stained-glass spray paint, acrylic enamel glass paint

Tools Brushes

Tips There are several paints available for painting glass. Search for the ones that will give the results you desire.

METAL

Prep Wire Brush to remove debris. Sand with 150-grit sandpaper for grab and wipe with damp cloth, dry before spraying paint.

Paint Spray paint for metal

Tools Masking tape for any sharp edges. Gloves for hand protection.

Tips Try creating texture with Krylon textured spray paints.

PLASTIC

Prep Sand with 150-grit sandpaper to increase grab of paint. Wash or wipe with damp cloth.

Paint Plastic spray paint.

Tips Apply multiple thin coats of spray paint for even look.

Encaustics | *Follow the steps to create a piece of encaustic artwork.*

MATERIALS flat electric griddle Enkaustikos Hot Sticks Enkaustikos Anodized Aluminum Plate 1" (2.5cm)
natural bristle utility paint brush print paper paper towel brayer (optional) Slick Wax or Soy Wax (for clean up)

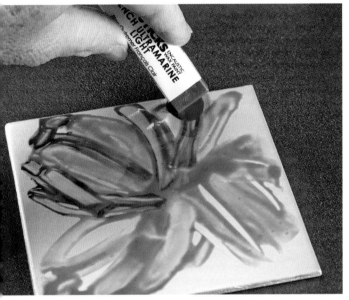

1 DRAW YOUR DESIGN

Remove the protective film from the printing plate and place it on the electric griddle. Set the temperature between 150°F and 175°F. The lower the temperature, the more control you will have over your paints. You may wish to place a single layer of paper under your plate to help it stay in place and to help with registrations.

Using the tip of the Hot Sticks, draw your design onto the printing plate. The paint will easily melt onto the plate. The slower you move the Hot Stick across the plate, the more paint is laid down. Allow the different colors you use to come in contact with one another to create color mixes. While the paint is on the plate it will stay liquefied. You may use a brush at any time to add more paint to your printing plate or to move the paint around to create detail. Once you have finished creating your design on the plate, you can use the end of your paint brush to draw back into the wax.

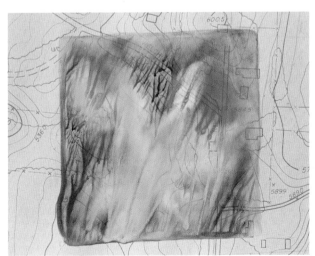

2 SKETCH AND COLOR

Once you are satisfied with your design on the plate, place your printmaking or collage paper onto the plate, positioning the paper so the plate is centered beneath it. The wax paint will be absorbed by the paper. If you need to apply extra pressure, lay a sheet or two of paper towel over the paper while it's still on the plate and use a brayer to roll gently over the surface. You have transferred the image onto your paper; lift the corners of the print and gently peel the paper away from the plate. Lay your encaustic print face up to cool!

LOVE CHILD
Collage resources, matte medium, acrylic paint and graphite pencil on
mixed-media board, 12" × 16" (30cm × 41cm)

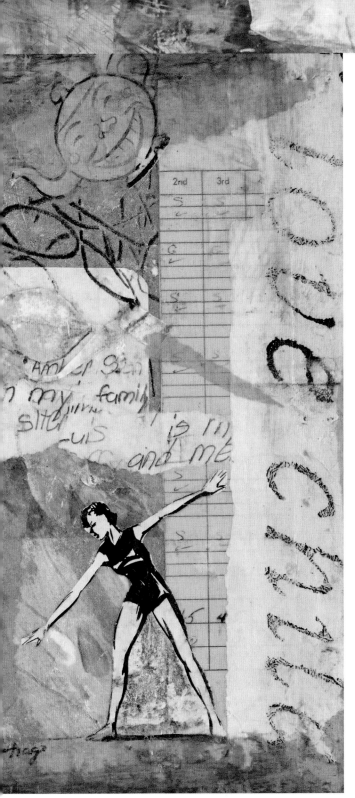

CHAPTER EIGHT
GALLERY

The secret to creating successful mixed-media artwork is the willingness to let go. Allow your inner creativity to be your guide and enjoy the journey. Whether you are expressing an idea or telling a story, the beauty of mixed media is in the lack of rules. Remain loyal to your beliefs and follow the basic fundamentals to create artwork that truly reflects who you are as an artist.

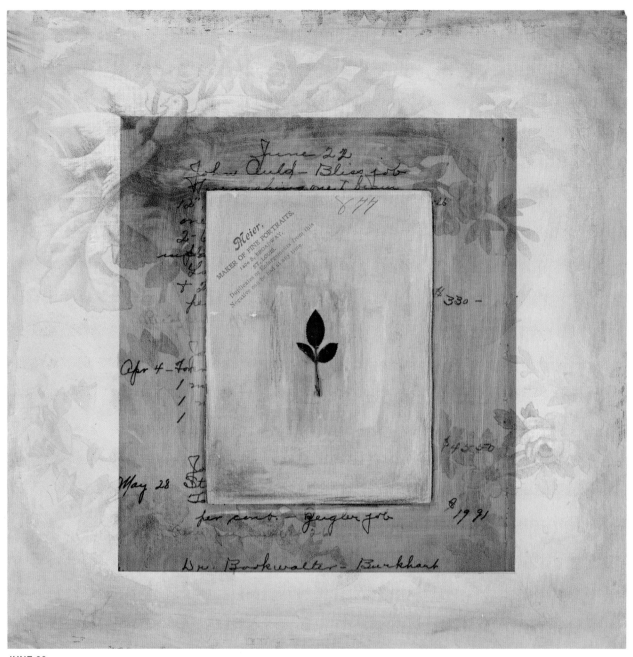

JUNE 22
Wallpaper, collage resources, vellum, dried leaf, acrylic paint and matte
medium on hardwood panel, 12" × 12" (30cm × 30cm)

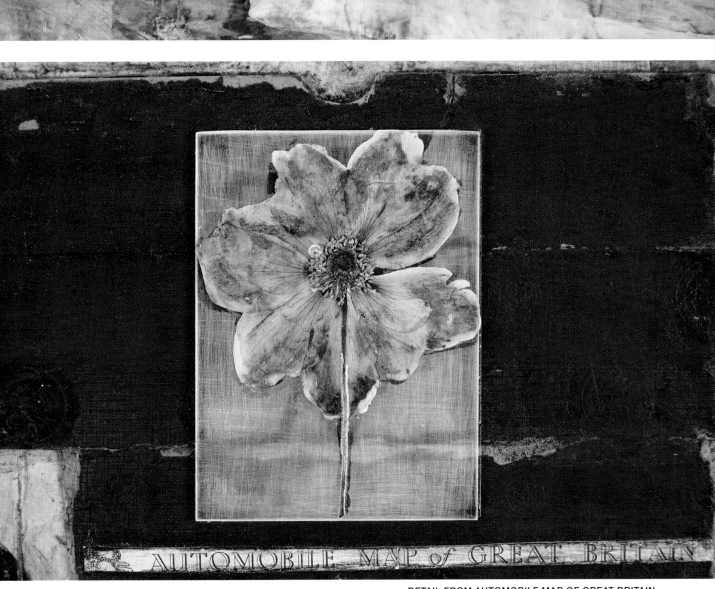

DETAIL FROM AUTOMOBILE MAP OF GREAT BRITAIN
Pressed flower on Plexiglas, 16" × 20" (41cm × 51cm)

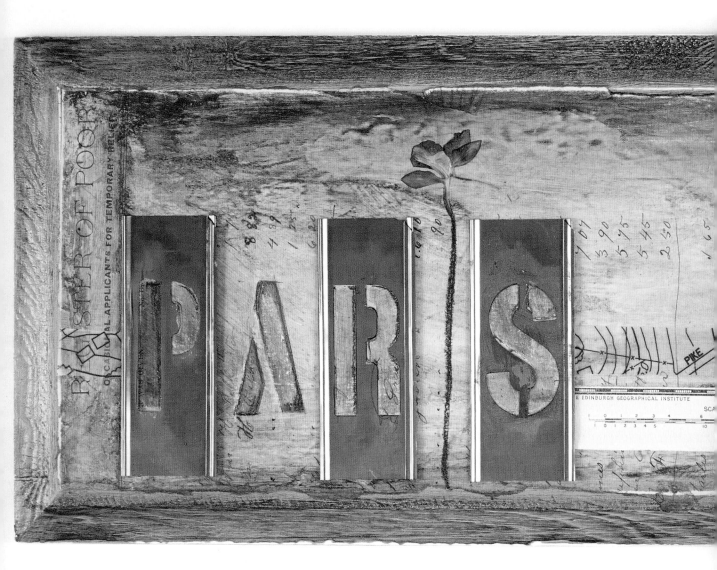

PARIS
Grafix Rub-onz, Grafix double-tack self-adhesive film, graphite pencil, acrylic paint, ephemera, vintage postcard, matte medium, wood frame, metal stencils and sandpaper on a wooden shelf prepped with white gesso, 24" × 8" (61cm × 20cm)

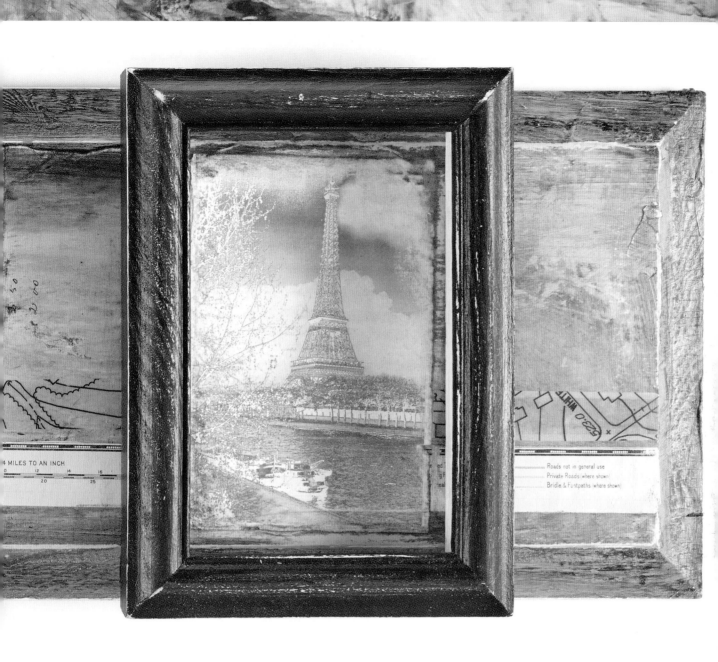

AUTOMOBILE MAP OF GREAT BRITAIN
Plexiglas, pressed flower, stencil, gloss medium and varnish, Grafix
Rub-onz, Grafix double-tack self-adhesive film, graphite pencil, acrylic
paint, ephemera, vintage map, liquid matte medium and sandpaper on
Ampersand panel, 16" × 20" (41cm × 51cm)

PREGNANT MOTHERS
Grafix Rub-onz, Grafix double-tack self-adhesive film, graphite pencil,
acrylic paint, ephemera, vintage postcard, liquid matte medium, wood
frame, metal stencils and sandpaper on deckle-edge paper and fabric,
24" × 30" (61cm × 76cm)

Compounds:
Potassium dichromate - $K_2Cr_2O_7$. This is the only important compound. It is

seen as large orange red crystals. used as an oxidizing agent.

1. Lead: Symbol - Pb. Atom
207.22.
Physical Properties: Lea
heavy metal with a bright,
It is soft, malleable and h
ing point.
Occurrence: Lead occurs
galena, PbS, although there
bonates, sulfates, and othe
Preparation:
(1) The sulfide is melt
iron.

$$PbS + Fe = Pb + Fe$$

Lead is heavier tha
sinks to the bottom.
(2) The ore is roasted
the PbS is changed to PbO an
it is heated in a closed fur

$$2\ PbO + PbS = 3\ Pb$$
$$PbSO_4 + PbS = 2\ P$$

Chemical Properties: Not
any extent by oxygen of the
ordinary conditions. HCl an
no effect. There are no imp
tions.
Uses: Lead foil, batter
loys.
Compounds:
(1) Lead oxide - lithar
pale yellow powder used as p

WELCOME
Collage materials, autograph book cover, Victorian sticker, glass test tubes (filled with metal safety pins), gloss sealer, acrylic paint and matte medium on plywood panel, 12" × 12" (30cm × 30cm)

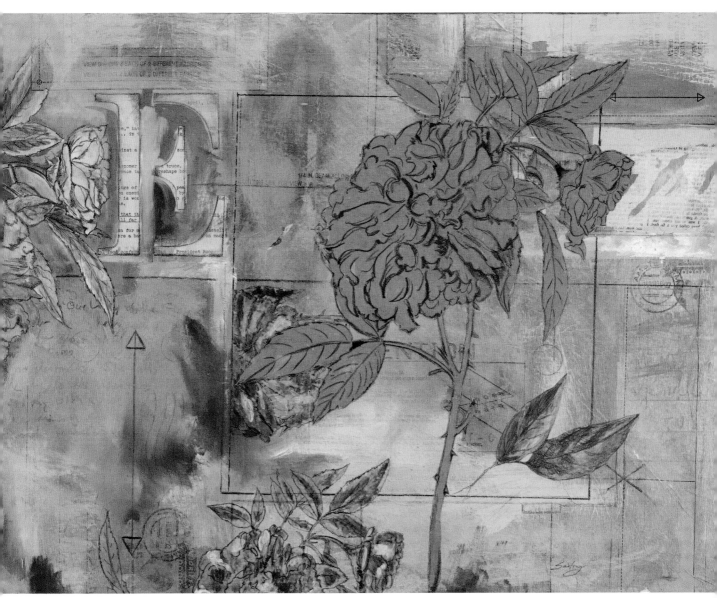

BEIGE FLOWERS
Acrylic paint, matte medium, black fine tip marker, graphite pencil,
collage resources, medium-weight drawing paper, Grafix Dura-Lar
matte, background from vintage postcards and pattern paper stencil,
and Grafix double-tack mounting film on hardwood panel, 18" × 24"
(46cm × 61cm)

MAKER OF FINE PORTRAITS
Wallpaper, vintage photo frame, vellum, dried leaf, collage materials,
acrylic paint and matte medium on hardwood panel, 12" × 12"
(30cm × 30cm)

BEAUTIFUL DIXIE
Piano player music scroll, book cover, collage resources, vellum, dried
leaf, acrylic paint and matte medium on hardwood panel, 11" × 14"
(28cm × 36cm)

DECISIONS
Vintage book covers, Beacon 3-in-1 glue, self-leveling gel, black gesso, polymer varnish with UVLS in satin finish, bird image, Grafix double-tack self-adhesive film, acrylic paint, ephemera and sandpaper on a cabinet door, 26" × 13" (66cm × 33cm)

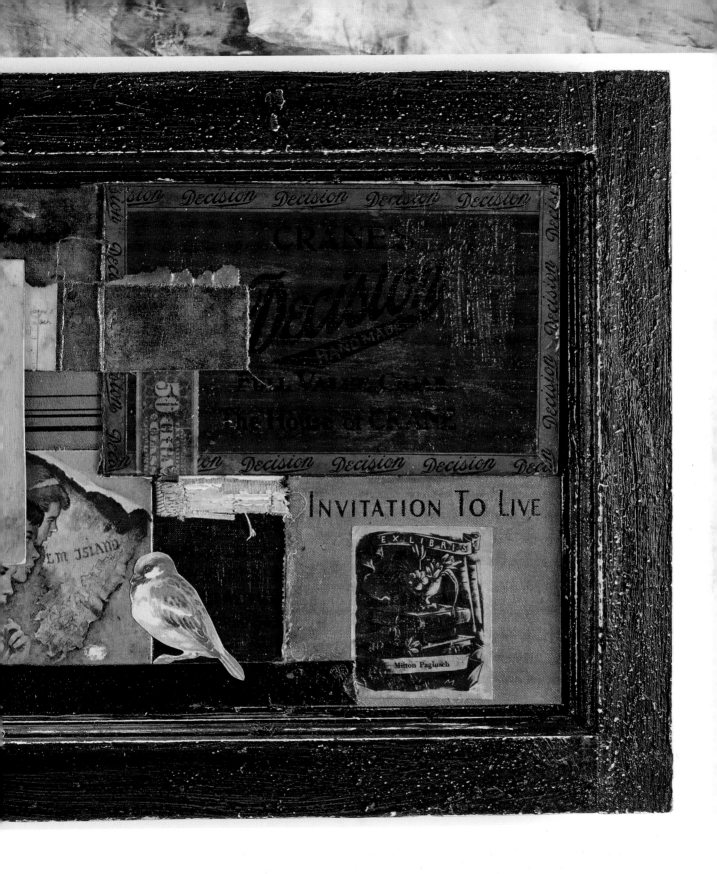

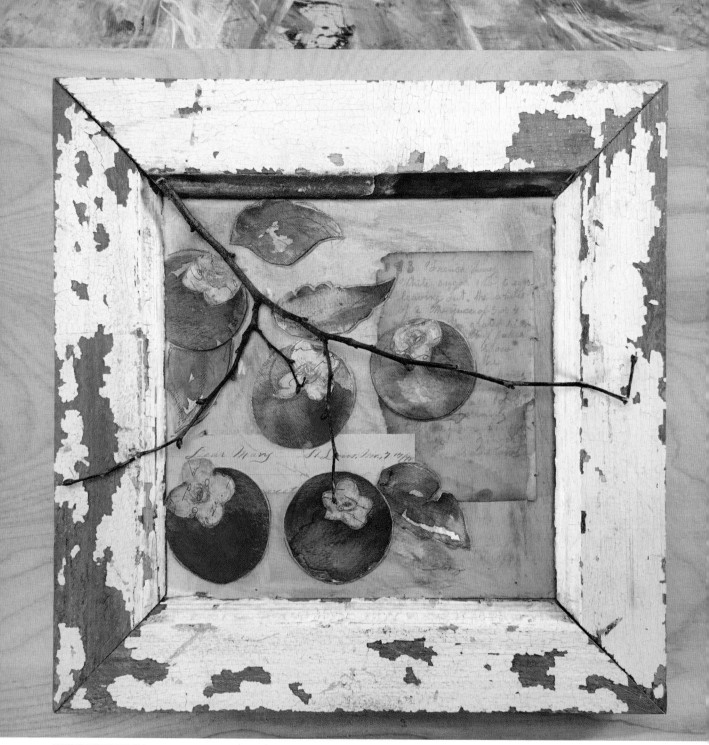

NATURE'S BRANCH
Collage resources, watercolor painting, tree branch, matte medium and
glue dots on wood panel, 8" × 8" (20cm × 20cm)

BITS & PIECES
Fabric, paper, artwork and collage resources sewn onto strips of natural muslin

LOOK
Ephemera, matte medium, acrylic paint, Rub-onz transfers printed
from gingko leaves and wood block on birchwood panel, 24" × 36"
(61cm × 91cm)

RED FLOWER
Acrylic paint, paper, matte medium, graphite pencil and satin varnish on
canvas, 24" × 36" (61cm × 91cm)

INDEX

a content + ecommerce company

Other fine North Light Books are available from your favorite bookstore, art supply store or online supplier. Visit our website at fwcommunity.com.

18 17 16 15 14 5 4 3 2 1

DISTRIBUTED IN CANADA BY FRASER DIRECT
100 Armstrong Avenue
Georgetown, ON, Canada L7G 5S4
Tel: (905) 877-4411

DISTRIBUTED IN THE U.K. AND EUROPE
BY F&W MEDIA INTERNATIONAL LTD
Brunel House, Forde Close, Newton Abbot, TQ12 4PU, UK
Tel: (+44) 1626 323200, Fax: (+44) 1626 323319
Email: enquiries@fwmedia.com

DISTRIBUTED IN AUSTRALIA BY CAPRICORN LINK
P.O. Box 704, S. Windsor NSW, 2756 Australia
Tel: (02) 4560-1600; Fax: (02) 4577 5288
Email: books@capricornlink.com.au

ISBN 13: 978-1-4403-3296-8

Edited by Christina Richards
Designed by Wendy Dunning
Photography by Christine Polomsky
Production coordinated by Jennifer Bass

Metric Conversion Chart

To convert	to	multiply by
Inches	Centimeters	2.54
Centimeters	Inches	0.4
Feet	Centimeters	30.5
Centimeters	Feet	0.03
Yards	Meters	0.9
Meters	Yards	1.1

ABOUT THE AUTHOR

Kimberly Santiago ia s graduate of Austin Peay State University and hold a degree in fine arts, with a concentration in graphic design. She began her career as a graphic designer and was elated to be recognized in *HOW Design Magazine*'s self-promotion issue. She continued to work in the design field and won several other awards and competitions, including, a Conquer Paper Design Contest. Her winning piece traveled to the Wiggins Teape Paper Point exhibition at Convent Garden and Butlers Wharf in London, and continued on to a venue in Paris.

Kimberly eventually transitioned to teaching and later became a department chair in graphic design and fine art at O'More College of Design in Franklin, Tennessee. She is the author of *Collage Playground* (F+W Community, North Light Books, 2010) and is featured in *Crafty Birds* (F+W Community, North Light Books, 2013) and *Collage Crafts Gone Wild* (F+W Community, North Light Books, 2013).

Kimberly currently works from her studio, teaching workshops and creating new art. She lives near Nashville, Tennessee.

ACKNOWLEDGMENTS

Thank you to Christina Richards, Christine Polomsky, Kristin Conlin, Tonia Jenny and the designers at F+W Media, Jodi L. O'Dell at Golden Artist Colors (GAC), Andrea Pramuk at Ampersand Art Supply, Kathryn Bevier at Enkaustikos Wax Art Supplies, Travis Pigg Territory Manager SLS Art Supply and the kind folks at Canson, Strathmore and Grafix.

DEDICATION

Abbie Marie Deaner
forever 8

Ideas. Instruction. Inspiration.

Receive FREE downloadable bonus materials when you sign up for our free newsletter at artistsnetwork.com/Newsletter_Thanks.

Alternative Art Journals With Margaret Peot

NORTH LIGHT DVD | an artistsnetwork.tv production

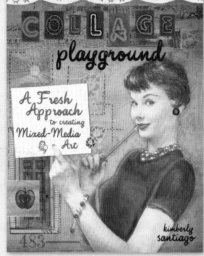

COLLAGE playground

A Fresh Approach to creating Mixed-Media Art

kimberly santiago

Watercolor Masking Tips & Techniques

Condense Tonal Values for a Striking Composition

the Artist's magazine

Celebrating the 30 Winners of Our Annual Art Competition

Giclées: Can They Enhance Your Career?

December 2013
www.artistmagazine.com

Find the latest issues of *The Artist's Magazine* on newsstands, or visit artistsnetwork.com.

These and other fine North Light products are available at your favorite art & craft retailer, bookstore or online supplier. Visit our websites at artistsnetwork.com and artistsnetwork.tv.

 Follow North Light Books for the latest news, free wallpapers, free demos and chances to win FREE BOOKS!

Visit artistsnetwork.com and get Jen's North Light Picks!

Get free step-by-step demonstrations along with reviews of the latest books, videos and downloads from Jennifer Lepore, Senior Editor and Online Education Manager at North Light Books.

Jen's PICKS

Get involved

Learn from the experts. Join the conversation on

WetCanvas